SAN DIEGO
DRAG RACING
AND THE
BEAN BANDITS

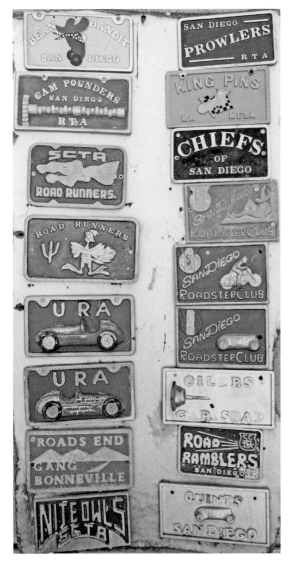

Joaquin Arnett's collection of car club plates is pictured here. Each member was given a plate upon membership. Arnett ran under the name of many of these clubs at the dry lakes before forming his own club the Bean Bandits with cofounder Mike Nagem. Arnett's daughter Jackie mentioned that of all the photographs in this book, he would probably be most happy to see this one included. (Courtesy of Emmanuel Burgin.)

FRONT COVER: Taken in 1953 at Paradise Mesa Drag Strip is the trophy presentation to Carlos Ramirez, the driver for the Bean Bandits that day. Trophy girls are (from left to right) Jo Morrow and Jackie Smithwick. Behind the trophy is Bean Bandit copresident, chief builder, and future Drag Racing Hall of Famer Joaquin Arnett. (Courtesy of Ruben Lovato.)

COVER BACKGROUND: A Bean Bandit twin-engine dragster is pictured at Paradise Mesa drag strip. (Courtesy of Ruben Lovato.)

BACK COVER: Bean Bandits are surrounded by racing trophies at Scott's Top Shop. (Courtesy of Ruben Lovato.)

SAN DIEGO DRAG RACING AND THE BEAN BANDITS

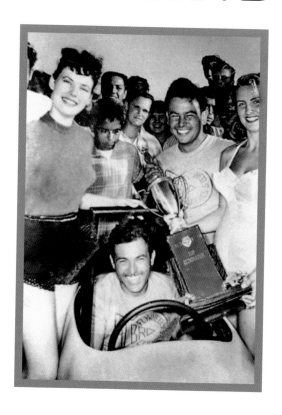

Emmanuel Burgin, Colleen M. O'Connor,
and Susan Wachowiak

ARCADIA
PUBLISHING

Published by Arcadia Publishing
Charleston, South Carolina

Printed in the United States of America

Library of Congress Control Number: 2017947341

For all general information, please contact Arcadia Publishing:
Telephone 843-853-2070
Fax 843-853-0044
E-mail sales@arcadiapublishing.com
For customer service and orders:
Toll-Free 1-888-313-2665

Visit us on the Internet at www.arcadiapublishing.com

To Joaquin Arnett and the Bean Bandits
and to all those pioneers of drag racing
imbued with the American can-do spirit.

CONTENTS

ACKNOWLEDGMENTS

Foremost thanks belong to the Joaquin Arnett family members, Viola, Jackie and Jeff for blessing the launch of this project, with access to their lifetime friends, private family albums, artifacts and stories.

Thanks also belongs to Ruben Lovato, official Bean Bandit photographer, who saved countless photographic negatives that served as the core of this book. He corralled other Bean Bandits club members to aid in chronicling their journey from street-smart kids to national championship racers.

Without the help of Bill Freeman and his historical notebook, Mike Uribe and his address book of drag racing enthusiasts, and the collective knowledge and insights of Pat Durant, Fred Angelo, Fred Martinez, Robert Martinez, Richard Lux, Elias Ponce, Derby Pattengill, and Dan Waldrop, this story might never have been discovered.

Our sincere thanks to racing legend Jerry Baltes, whose excitement helped propel this book. He sent pictures, stories, and memorabilia and influenced many racing friends to share their San Diego experiences.

Recognition is due to Andy Bekech, the San Diego Prowler Club historian whose personal collection of original and reprinted art by Bob McCoy and pictorial website proved invaluable.

We are indebted to racing greats Jess Van Deventer (and his executive assistant Desiree Peters), Dode Martin, and Emery Cook's son Ernie for sharing their memories, as well as Bill Rennie, Red Gref, Johnny McDonald, Roland Leong, Chuck Einolander, Gordy Gibbs, Manuel Maldonado, Max Romero, Dick Lechien, Lou Bingham, Cameron Evans, and Nicole Szawlowski. National Hot Rod Association's Steve Gibbs, Greg Sharp, and Larry Fisher also provided memorabilia essential to this book.

A special shout out goes to the Con Pane Bakery, where the authors and contributors consumed incomparable sandwiches and Mexicana mochas while sorting through hundreds of fragile photographs and collectables.

Thanks for the generous support and sage help of Barry Pollard's Urban Collaborative Project and Klonie Kunzel, chair of the Point Loma La Playa Trail Association.

Finally, recognition goes to the Jewish Community Foundation of San Diego, the San Diego County Board of Supervisors, and several anonymous donors for their generous financial support.

INTRODUCTION

San Diego drag racing has been at the forefront of this American sport from its inception. Drag racing was born in postwar Southern California from dreams filled with endless sunny skies, fast cars, beautiful girls, and the American can-do spirit.

What made the sleepy navy town of San Diego such a hot bed of drag racers, lakesters, and other speed demons?

Firstly, speed demons had been coming to San Diego ever since Barney Oldfield made his appearance here in 1907, and many followed—including Eddie Rickenbacker and Bob Burman, to name a few. Lakeside Inn owner John H. Gay built a track around the lake to attract guests and tourists, and they came by the thousands. Many of the San Diego drag-racing pioneers would grow up with these stories. Every kid wanted a jalopy and to go fast. Joaquin Arnett and the Bean Bandits were no different.

Once Arnett's dad mentioned a "race on the salt sea," and that's all the 15 year old needed to hear. He jumped into his car (already with a valid driver's license, but that's another story), rounded up his future Bean Bandit friends, and headed to the races. A couple of days later upon his return, his angry father asked him where he had been, and Young Arnett replied, "Salt Lake City, but there was just this big car with big wheels going around in a circle." His father shook his head and replied, "I said the 'Salton Sea.'" There were some boat races on the Salton Sea—not Salt Lake City. "Boy, was he mad," Arnett stated with a grin and a fond memory.

Many years later, he would find out that what he had witnessed as a young man was Sir Richard Cobb, who owned the land speed record and was then attempting to break the endurance record. Fifteen years later, Arnett, along with his Bean Bandits, began their lifelong pursuit of the world land speed record.

Secondly, in San Diego especially, these young racers were not only living the Southern California dream, but they were also living it surrounded by naval and aerial stations along with their commercial counterparts. With speed and ingenuity in the water and in the air above, these young men were inspired and spurred on to innovate. And regarding the military, not only did it inspire and influence this postwar generation, but it had also taught and trained many of them during the war. Moreover, after the war military salvage yards and surplus stores provided inexpensive equipment and materials to ply their passion. It would also supply them with their first drag strip by the way of an old abandon airfield.

The ground was fertile, and from that came the early innovators and champions the likes of Joaquin Arnett and the Bean Bandits, Dode Martin and Jim Nelson of the Dragmasters, Paul Schiefer of Schiefer Manufacturing Company, Dave Schneider of Schneider Racing Cams, Crower Cams & Equipment Co., Emery Cook of the record-breaking Cook-Bedwell dragster, later champions like Jerry Baltes and Jess Van Deventer. Also, we must not forget a tip of the hat

to the San Diego Prowlers Hot Rod Club, formed in 1947—the longest, continuously existing car club in America.

Of these many San Diego champions, Joaquin Arnett and Bean Bandits stand out if for no other reason than they won the first National Hot Rod Championship event in 1953. But their legacy is long and began on the dry lakes in the late 1940s, then to drag racing and again a return to land speed racing on the dry lakes and ultimately to the salt flats of Bonneville in pursuit of the grand prize of the world land speed record. Arnett and the Bean Bandits would win countless championships and set several drag-racing track records across the country and land speed class records at the lakes and at Bonneville.

Arnett would also come to be known as a master welder and body man, building, chopping, and, sectioning cars for many drag racers and hot rodders. His work can be seen to this day in automotive museums. A chapter is dedicated to this Drag Racing Hall of Famer.

And so, as Arnett and all those young postwar speed-demon pioneers of San Diego raced, tested and innovated from the dry lakes of Muroc and El Mirage to the "drag strip of many firsts" Paradise Mesa all in an effort to go faster, they were, all the while, invigorating a burgeoning automotive industry with engineering feats and innovative designs. San Diego drag racers were part and parcel of the Southern California car cultural, and this book is an attempt to shed a little light on their story.

TRAINING GROUNDS

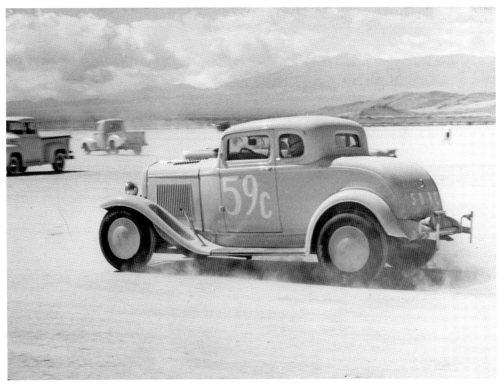

Many drag racers began racing the dry lakes of Muroc and El Mirage postwar before there was official drag racing. Here is Lou Bingham of the San Diego Roadster Car Club in his 1932 five-window coupe. Bingham sold the car in the 1980s. Then, sometime in the 1990s, he was contacted by the owner who brought it by from Texas on his way to a car show. Bingham said it still had the original Kaiser Top Shop upholstery. (Courtesy of Lou Bingham.)

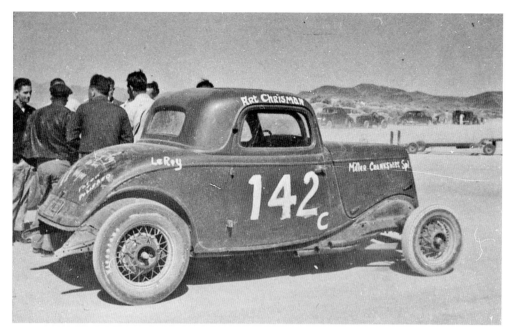

Pictured here is a Chrisman fender-less coupe at El Mirage. It must be cold, as everyone is wearing their jackets. Art Chrisman, out of Los Angeles, would become one of the heavyweights of drag racing and a chief rival to Joaquin Arnett and the Bean Bandits and Dode "Dragmaster" Martin. (Courtesy of Ruben Lovato.)

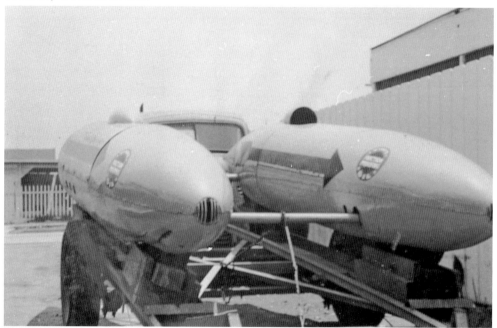

Innovation is the name of the game. Here is Howard Johansen's twin-belly tank on its trailer heading off to the lakes. Belly tanks were used for streamline effects. In this particular image, the driver sits in one belly tank, with the engine in the other. (Courtesy of Ruben Lovato.)

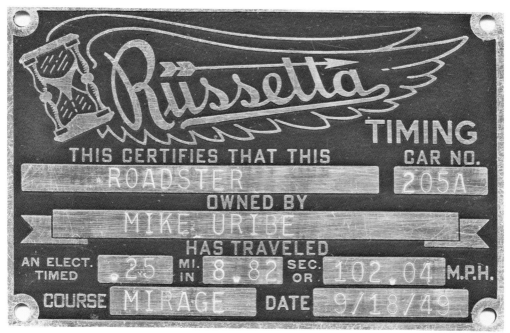

Here is a Russetta speed plaque given to Mike Uribe of the Cam Pounders Club for a successful run in his roaster at El Mirage. These plaques were a badge of honor and highly coveted. Russetta Timing Association allowed one to run whatever they brought, unlike the Southern California Timing Association (SCTA), which had classifications and safety rules. (Courtesy of Mike Uribe.)

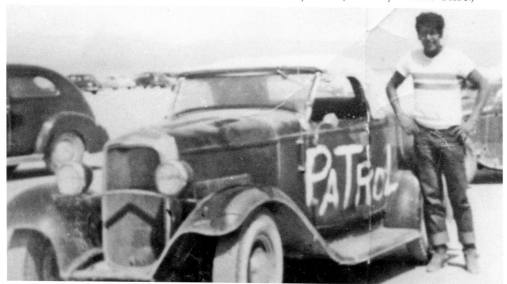

Mike Uribe is pictured in 1949 at El Mirage dry lakes with his 1932 Ford roadster. The roadster is equipped with a Ford flathead, full race cam, and twin carburetors. The Cam Pounders disbanded shortly after this photograph was taken, as many were drafted into the Korean War. Mike became a commercial fisherman. Several Cam Pounders, including Joaquin Arnett and Mike, would then form the Bean Bandits and join the SCTA. (Courtesy of Mike Uribe.)

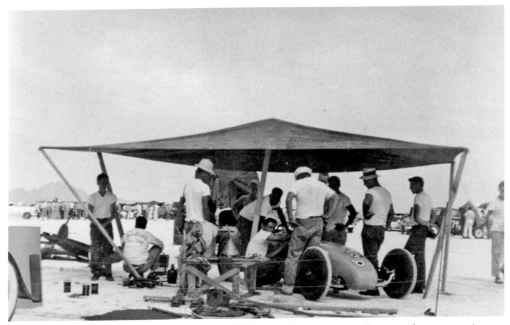

The Bean Bandits are pictured at El Mirage 1955 under the canopy working on the roaster. Arnett started out on the dry lakes and never lost the thrill of going all out and testing the limits of an engine and car. If he was not at a drag strip, the lakes are where one could find him and the Bean Bandits. (Courtesy of Fred Angelo.)

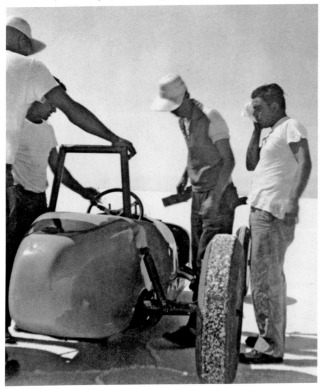

In this 1955 image captured at El Mirage, Arnett holds a rag to his face to stop the bleeding. The clutch blew up sending pieces bouncing off a tire to find him. Years earlier, a clutch blew up with the flywheel just missing his head. That was the moment Arnett said he began thinking of putting the engine behind him. Not long after, the rear-engine Bean Bandit dragster made its appearance at Paradise Mesa drag strip. (Courtesy of Fred Angelo.)

TRAINING GROUNDS

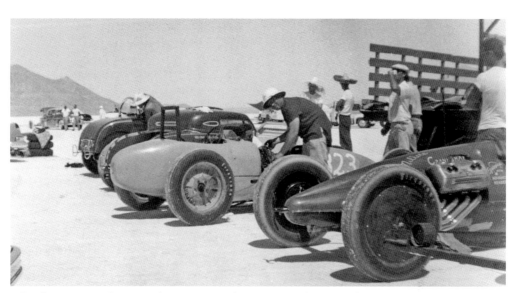

Like the variety of cars in the pit area—dragsters, roadsters, and coup—on a hot day at the lakes, so were the sun blockers, pith helmets, straw hats, newsboy caps, and sombreros seen in this 1955 at El Mirage. The men who plied their passion on these lakes before and after the war were independent, and as different as the cars they drove and the hats they wore, they all had a love to go fast. (Courtesy of Fred Angelo.)

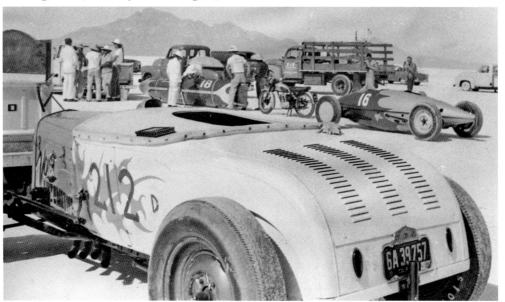

This image shows additional examples of the variety cars at the lakes; a roadster is in the foreground, the No. 16 is a belly tanker, and the No. 18 is a streamliner. These belly tankers, or drop tanks, were used during the war to carry extra fuel for B-52 bombers. When they were empty of fuel, they were dropped. Belly tankers could be found in the salvage yards after the war and were perfect for those who returned from the war with the knowledge of aerodynamics. (Courtesy of Ruben Lovato.)

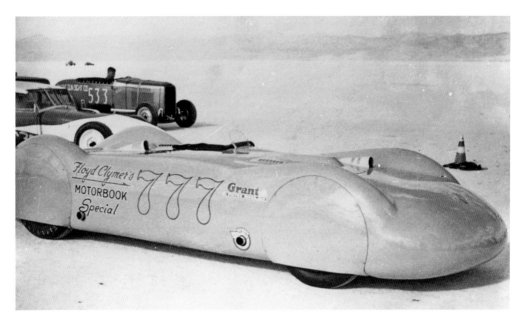

The Floyd Clymer's Motorbook Special streamliner is seen at El Mirage. Built by Bill Kenz and Roy Leslie, Denver Speed Shop owners, the streamliner ran with twin 296-inch flatheads. Kenz-Leslie would build their own streamliner with three Ford flathead V-8s and set records throughout the 1950s. Among its many performance parts were San Diegan Paul Schiefer's aluminum clutch. (Courtesy of Ruben Lovato.)

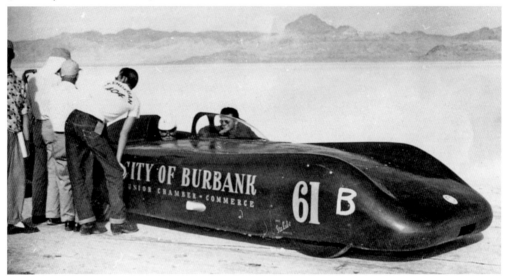

The "City of Burbank" streamliner sports the aerodynamic look at El Mirage. It is another inspiration from the war years, as many veterans had become acquainted with the new science. It was inspired the previous year by the Kenz-Leslie streamliner. Bill Davis and George Hill of the Glendale Stokers Club teamed with experienced car designer Dean Batchelor and came up with this design. It set a class international speed record and returned the record to the United States; it was the first for an American since 1928. (Courtesy of Ruben Lovato.)

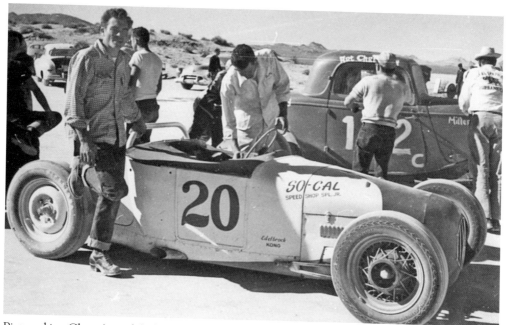

Pictured is a Class-A modified roadster of the So-Cal Speed Shop Racing Team; it was one of four cars by the So-Cal Speed Shop. The shop was started by Alex Xydias in 1946. In 1949, Xydias not only competed in the first Bonneville event sanctioned by SCTA, but he also had top speed of the meet at 187 mph in the Xydias and Dean Batchelor So-Cal Special Streamliner. (Courtesy of Ruben Lovato.)

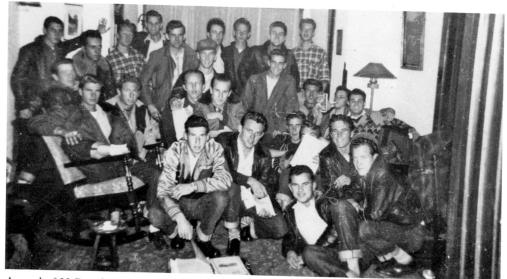

A total of 22 Prowlers, plus a few guests, are pictured at their initial meeting in 1948 at member Frank Wilkinson's house. Wilkinson is far right in the back row. Many of these young men were running on the dry lakes and would become part of the San Diego car cultural. Some members joined the San Diego Timing Association, and others worked to promote car safety among hot rodders. The club is the oldest, longest-running car club in America. (Courtesy of the Prowlers.)

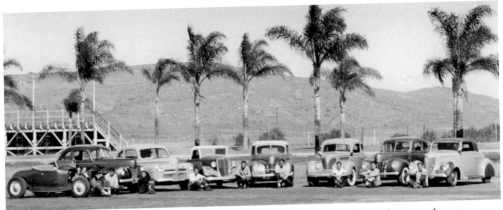

It was not all racing for all car clubs. Some like the Prowlers entered car shows and went on car runs. Car clubs and the public events they attended and promoted helped change the outlaw reputation of hot rodders and assisted civic-minded leaders in persuading those in authority to allow safe places to race. (Courtesy of the Prowlers.)

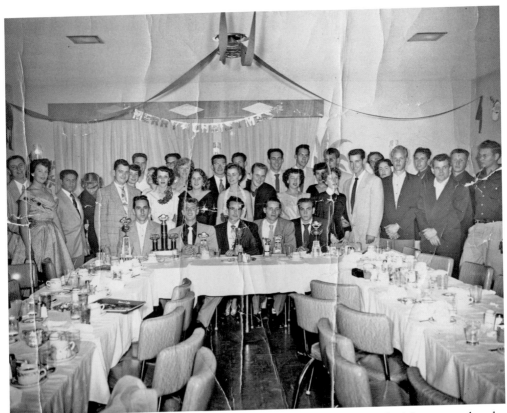

The Prowlers attend an award dinner for the season's points winners. Each club competed at the lakes and drag strips. Each member would accumulate individual points as well as team points. Future team historian Andy Bekech is in the center right of the back row, wearing a tie, a light-colored jacket, and big smile. (Courtesy of the Prowlers.)

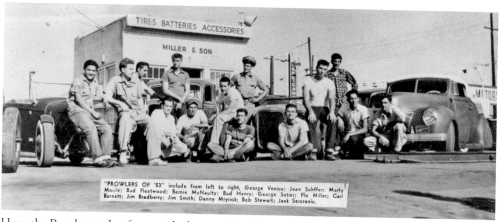

Here, the Prowlers gather for a quick photograph in front of Miller and Sons on University Boulevard in 1953. From left to right are George Venice, Jean Schffer, Marty Moore, Bud Fleetwood, Bernie McNaulty, Bud Henry, George Sotier, Flo Miller, Carl Burnett, Jim Bradberry, Jim Smith, Jimmy Mryrick, Bob Stewart, and Jack Sercranic. (Courtesy of the Prowlers.)

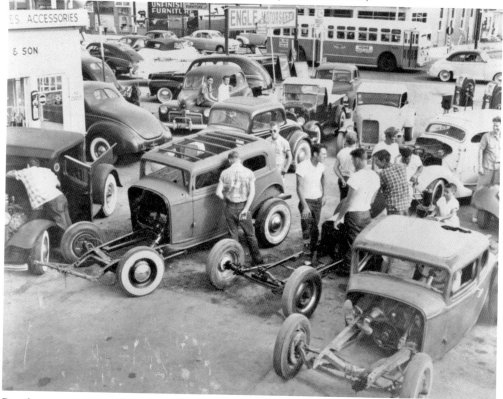

Prowlers meet at Flo Miller's Gas Station, located at the corner of Seventh and University Avenues, on a Saturday afternoon in 1953. What is significant about this photograph is the young Prowler at far right in the white long-sleeve shirt. That is Bob McCoy, who would become a well-known artist of the hot rod culture and the Southern California lifestyle. His poster of Joaquin Arnett and the Bean Bandit cars is included in this book. (Courtesy of the Prowlers.)

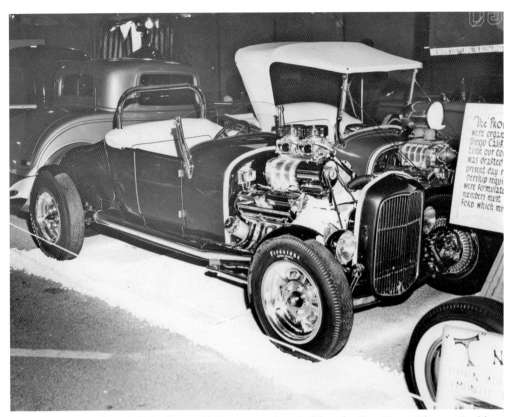

Pictured is a Prowlers club display in 1960 at a car show held at the San Diego Electric Building in Balboa Park. The Prowlers were known for their beautiful coupes and roadsters. Their cars won many awards over the years and would grace the covers of car magazines throughout the 1950s and 1960s. (Courtesy of the Prowlers.)

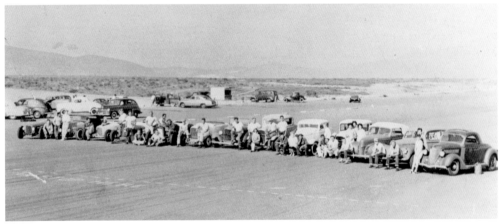

Here are all the Prowlers' cars that ran at Paradise Mesa Drag Strip that day. It is hard to see that the 10th Prowler from the left in profile is Emery Cook. If one did not belong to a club, they could still earn points for them. It seems Cook was freelancing this day. It was called backed then as it is today, "having a ringer." (Courtesy of the Prowlers.)

TRAINING GROUNDS

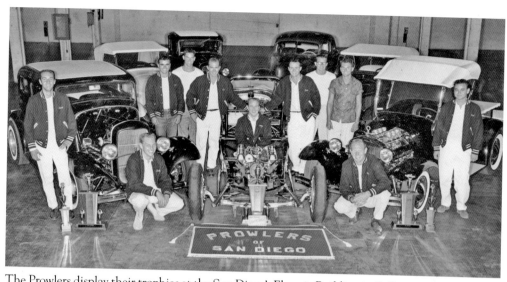

The Prowlers display their trophies at the San Diego's Electric Building in Balboa Park in the 1950s. From left to right are Clark Gette, Dick Minor, Tom Madrunga, Gary Osborn, Ed Thompson, Andy Bekech, Pete Morrow, Jim Bradberry, Willy Clark, Rusty Case, and Fred Smith. (Courtesy of the Prowlers.)

The Knuckle Busters of Coronado seen here from left to right are Gene Cowley, Bill Mull, Earl Bullock, Bill Dugger, and John Murphy; (second row) Reed MacNally, Biff Barrett, and Fred Fish. The Knuckle Busters were involved with the newly formed San Diego Timing Association (SDTA) in the movement to protect and educate all the driving public by promoting safety to its members and those in its community. They planned and hosted the First Annual Reliability Run. (Courtesy of Johnny McDonald.)

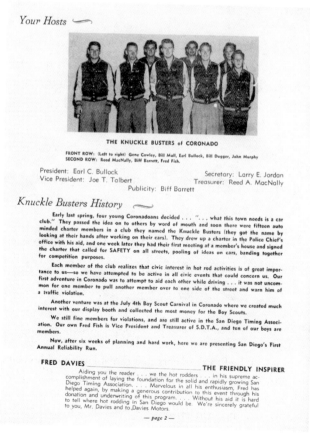

Your Hosts

THE KNUCKLE BUSTERS of CORONADO

FRONT ROW: (Left to right) Gene Cowley, Bill Mull, Earl Bullock, Bill Dugger, John Murphy.
SECOND ROW: Reed MacNally, Biff Barrett, Fred Fish.

President: Earl C. Bullock Secretary: Larry E. Jordan
Vice President: Joe T. Talbert Treasurer: Reed A. MacNally
Publicity: Biff Barrett

Knuckle Busters History

Early last spring, four young Coronadoans decided . . . ". . . what this town needs is a car club." They passed the idea on to others by word of mouth and soon there were fifteen auto minded charter members in a club they named the Knuckle Busters (they got the name by looking at their hands after working on their cars). They drew up a charter in the Police Chief's office with his aid, and one week later they had their first meeting at a member's house and signed the charter that called for SAFETY on all streets, pooling of ideas on cars, banding together for competition purposes.

Each member of the club realizes that civic interest in hot rod activities is of great importance to us—so we have attempted to be active in all civic events that could concern us. Our first adventure in Coronado was to attempt to aid each other while driving . . . it was not uncommon for one member to pull another member over to one side of the street and warn him of a traffic violation.

Another venture was at the July 4th Boy Scout Carnival in Coronado where we created much interest with our display booth and collected the most money for the Boy Scouts.

We still fine members for violations, and are still active in the San Diego Timing Association. Our own Fred Fish is Vice President and Treasurer of S.D.T.A., and ten of our boys are members.

Now, after six weeks of planning and hard work, here we are presenting San Diego's First Annual Reliability Run.

FRED DAVIES _____ **THE FRIENDLY INSPIRER**

Aiding you the reader . . . we the hot rodders . . . in his supreme accomplishment of laying the foundation for the solid and rapidly growing San Diego Timing Association. . . . Marvelous in all his enthusiasm, Fred has helped again, by making a generous contribution to this event through his donation and underwriting of this program. . . . Without his aid it is hard to tell where hot rodding in San Diego would be. We're sincerely grateful to you, Mr. Davies and to Davies Motors.

— page 2 —

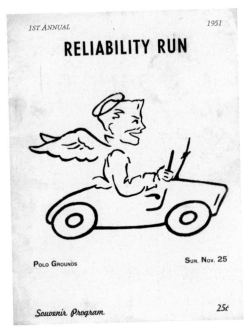

1ST ANNUAL 1951

RELIABILITY RUN

POLO GROUNDS SUN. NOV. 25

Souvenir Program 25¢

This is the cover for the program of the First Annual Reliability Run held at the Coronado Polo Grounds in 1951. Knuckle Busters member Fred Fish was the vice president of the SDTA, and 10 car members were also members of the timing association. (Courtesy of Johnny McDonald.)

This page of the Reliability Run program announces the formation of the SDTA It is interesting to read because it portrays the public angst that existed prior to official drag strips. Outlaw drag racing was taking the lives of people on the streets, and now there would be a safe place to race and spectate. (Courtesy of Johnny McDonald.)

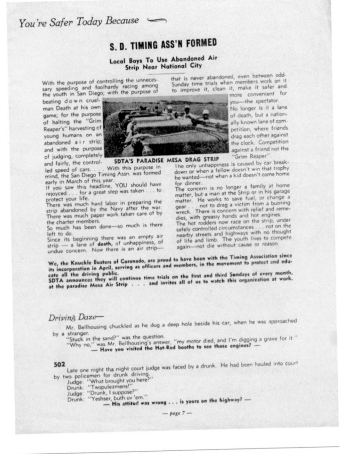

You're Safer Today Because

S. D. TIMING ASS'N FORMED

Local Boys To Use Abandoned Air Strip Near National City

With the purpose of controlling the unnecessary speeding and foolhardy racing among the youth in San Diego; with the purpose of beating down cruel man Death at his own game; for the purpose of halting the "Grim Reaper's" harvesting of young humans on an abandoned air strip; and with the purpose of judging, completely and fairly, the controlled speed of cars. . . . With this purpose in mind, the San Diego Timing Assn. was formed early in March of this year.

If you saw this headline, YOU should have rejoiced . . . for a great step was taken . . . to protect your life.

There was much hard labor in preparing the strip abandoned by the Navy after the war. There was much paper work taken care of by the charter members.

So much has been done—so much is there left to do.

Since its beginning there was an empty air strip — a lane of **death**, of unhappiness, of undue concern. Now there is an air strip—

SDTA'S PARADISE MESA DRAG STRIP

that is never abandoned, even between odd-Sunday time trials when members work on it to improve it, clean it, make it safer and more convenient for you—the spectator.

No longer is it a lane of death, but a nationally known lane of competition, where friends drag each other against the clock. Competition against a friend not the "Grim Reaper".

The only unhappiness is caused by car breakdown or when a fellow doesn't win that trophy he wanted—not when a kid doesn't come home for dinner.

The concern is no longer a family at home matter, but a man at the Strip or in his garage matter. He works to save fuel, or change a gear . . . not to drag a victim from a burning wreck. There is concern with relief and remedies, with greasy hands and hot engines.

The hot rodders now race on the strip, under safely controlled circumstances . . . not on the nearby streets and highways with no thought of life and limb. The youth lives to compete again—not die without cause or reason.

We, the Knuckle Busters of Coronado, are proud to have been with the Timing Association since its incorporation in April, serving as officers and members, in the movement to protect and educate all the driving public.

SDTA announces they will continue time trials on the first and third Sundays of every month, at the paradise Mesa Air Strip . . . and invites all of us to watch this organization at work.

Driving Daze—

Mr. Bellhousing chuckled as he dug a deep hole beside his car, when he was approached by a stranger.

"Stuck in the sand?" was the question.

"Why no," was Mr. Bellhousing's answer, "my motor died, and I'm digging a grave for it."

— Have you visited the Hot-Rod booths to see those engines? —

502

Late one night the night court judge was faced by a drunk. He had been hauled into court by two policemen for drunk driving.

Judge: "What brought you here?"

Drunk: "Twopulezmens!!"

Judge: "Drunk, I suppose?"

Drunk: "Yeshser, buth ov 'em."

— His attitud was wrong . . . is yours on the highway? —

— page 7 —

TRAINING GROUNDS

The is the cover of the *1953 Competition Rules and Regulations* book of the SDTA, operators of the Paradise Mesa Drag Strip. The strip from the beginning was well organized, designed, and staged with a state-of-the-art timing system from San Diegan Otto Crocker. Crocker had been timing Lakesters for many years and was the official timer for all land speed records at the Bonneville Salt Flats. (Courtesy of the Prowlers.)

Seen here is the cover of the SDTA book on *Paradise*; Paradise was so well organized that many of its "firsts" would become the standard across the country. Santa Ana Drag Strip, although the first drag strip, would adopt many of the rules and regulation that first began at Paradise, which was the second drag strip. Later, many of these rules and regulation would be included in the first nationwide regulations for the National Hot Rod Association (NHRA) in 1960. (Courtesy of the Prowlers.)

Seen here is the first logo of the SDTA. The president of the association was Mike Nagem, a service station owner; the secretary was Minoru Kojima, a National City dentist; and treasurer was Fred Davies, owner of Davies Motor Co., a car dealership. The starter was George Banks, a city civil servant. (Courtesy of the Prowlers.)

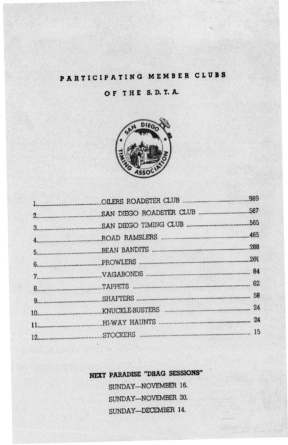

PARTICIPATING MEMBER CLUBS

OF THE S. D. T. A.

1.	OILERS ROADSTER CLUB	989
2.	SAN DIEGO ROADSTER CLUB	587
3.	SAN DIEGO TIMING CLUB	565
4.	ROAD RAMBLERS	465
5.	BEAN BANDITS	288
6.	PROWLERS	261
7.	VAGABONDS	84
8.	TAPPETS	62
9.	SHAFTERS	58
10.	KNUCKLE-BUSTERS	24
11.	HI-WAY HAUNTS	24
12.	STOCKERS	15

NEXT PARADISE "DRAG SESSIONS"
SUNDAY—NOVEMBER 16.
SUNDAY—NOVEMBER 30.
SUNDAY—DECEMBER 14.

The inside cover of the SDTA pamphlet shows the participating club members and their point totals. Oilers Roaster Club with Dode Martin lead in points, with 999. San Diego Roadsters Club with Lou Bingham is in second, with 587 points. Bandits are in fifth, and the Prowlers in sixth. (Courtesy of the Prowlers.)

TRAINING GROUNDS

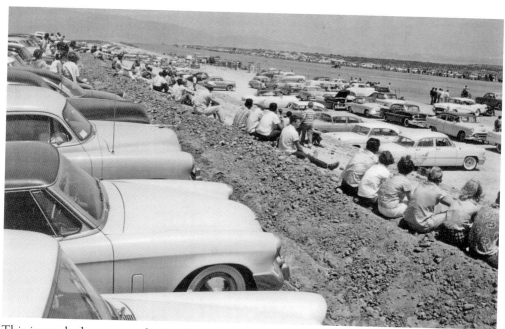

This image looks west on the Paradise Mesa Drag Strip. In the foreground are nice new cars. According to Prowlers historian Andy Bekech, these are more than likely the kids' parents' cars driven to Paradise. Also, the proximity of the strip to San Diego proper allowed families to take in the new American sport without much bother; it was as easy as heading to the beach. Spectators enjoy a nice elevated view of the strip. (Courtesy of the Prowlers.)

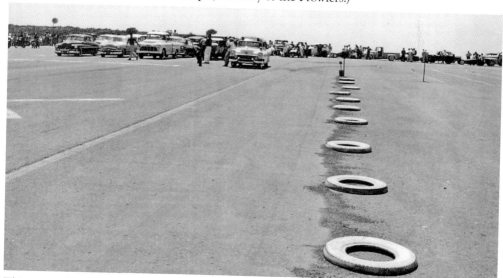

This view of Paradise Mesa Drag Strip looks east at the starting line. An ambulance is on the right. The staging line can be seen circling right. The first official racing event was held in March 1951, and according to the local *San Diego Union* reporter, "Thus a new San Diego County sport seems to be emerging." Races were to be held the first and third of each month. (Courtesy of the Prowlers.)

SAN DIEGO DRAG RACING AND THE BEAN BANDITS

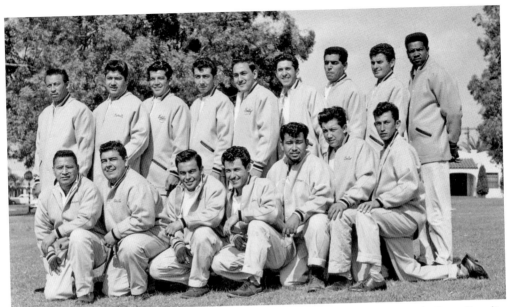

The Bean Bandits formed in 1949 after the Cam Pounders disbanded. In 1960, the Bean Bandits disbanded but were reformed in 1988 by Mike Nagem and Joaquin Arnett to pursue land speed records. From left to right are (first row) Ruben Lovato, Charles Elias, Joaquin Arnett, Carlos Ramirez, Pat Durant, Lalo Lopez, and Lee-Lee Ortiz; (second row) Donde Alzona, Robert Martinez, Eddie Espinoza, unidentified, Fred Angelo, Gus Montalvo, ? Estrano, Mike Nagem, and Harold Miller. (Courtesy of Ruben Lovato.)

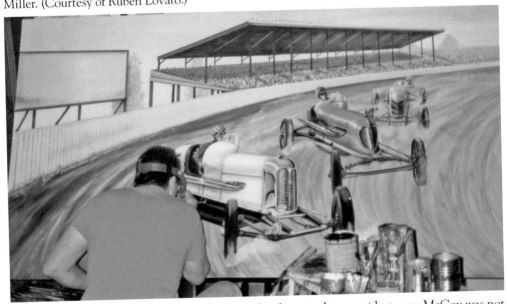

Bob McCoy is pictured in his studio at work on his favorite theme: midget cars. McCoy was not only an artist of the car culture, but he also participated. He raced midget cars, and as a member of the Prowlers Car Club he raced at Paradise Mesa Drag Strip with his iconic 1940 flamed, black Ford Tudor. (Courtesy of the Prowlers.)

TRAINING GROUNDS

BEAN BANDITS
IN PARADISE

You are Invited to Participate in the Special Events
for

WEDNESDAY, JULY 4, 1951

- Hot Rods
- 1951 New Cars
- Modified Roadsters
- Coupes
- Draggin' Machines

- Motorcycles
- Sedans
- Sports Cars
- Exhibition Drags
- Cycles vs. Cars

PARADISE MESA DRAGS
CONDUCTED BY THE SAN DIEGO TIMING ASSOCIATION
"A non-profit group organized for the safe operation of the Drag Races at the Paradise Mesa Air Strip"

1. **LOCATION** of the Drag Strip is 3 miles East of National City, off Eighth Ave.
2. **TROPHIES** will be awarded in each Competition Class for Winners of the Drags, and also for Fastest Speed of the day.
3. **J. O. CROCKER'S** famous 1000-second Bonneville Timer is used for all Recorded Speeds.
4. **HALF-MILE ROAD RACE** for Sports Cars on the Paved Strip.
5. **FASTEST** Quarter Mile paved strip in California with standing starts. (Art Chrisman's Miller Crank Special turned 117.34 Sunday, June 17.) There is a full three-tenths paved area for slowing down. The Paradise Strip is acclaimed the SMOOTHEST by top drivers who know!
6. **ADMISSION** is 50 cents per person. Entry Fee for Drags is 50 cents.
7. **TWELVE CLASSES** of Competition, so that any make, model, size of Car or Cycle will compete with like machines for fair competition.
8. **TIME TRIALS** will begin at 9 a.m. and the Competition Drags are scheduled to commence at 1 p.m. Trophy presentation at 4 p.m.

(Please rush your Entry to address below, so we may include your name in Program)

This is a flyer for one the first events at Paradise Mesa drags to be held July 4, 1951. Note the highlights: J.O. Crocker's famous 1,000-second Bonneville timer, fastest quarter-mile paved strip in California with standing starts, as well as the bullet point that reads, "Cycles vs. Cars." Cycles ruled for a while until dragsters became lighter and more powerful. (Courtesy of Johnny McDonald.)

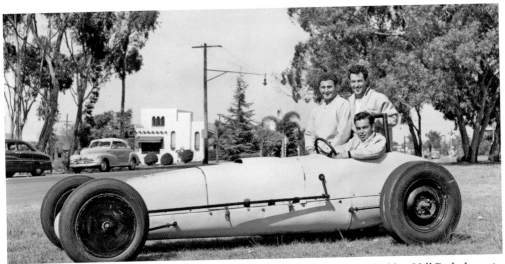

Seen here is the famous Bean Bandit dragster. This photograph taken in Golden Hill Park. Joaquin Arnett is in cockpit. Behind the dragster are Mike Nagem (left), co-president of the Bean Bandits, and primary driver Carlos Ramirez. Nagem, Arnett and Ramirez were names the nascent drag racing community would come to know. (Courtesy of Ruben Lovato.)

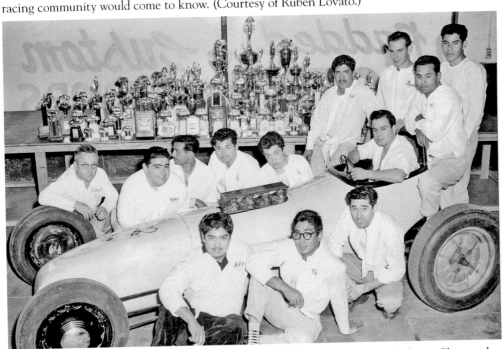

In this 1954 image taken in San Diego, the Bean Bandits are in Scott's Upholstery Shop with a few of their trophies. Many times, they would return the trophies to the promoter for a few dollars to have for gas money to return home. From left to right are (sitting in front of the car) Robert Martinez, Sammy Garcia, and Gus Montalvo; (in the car) Joaquin Arnett; (behind the car) M.R. Scott, Charlie Ellias, Mike Nagem, Albert Ortiz, Lalo Lopez, Andrew Ortega, Buddy Bunshoe, Fred Martinez, and "Ningy" Ningetta. (Courtesy of Ruben Lovato.)

BEAN BANDITS IN PARADISE

Pictured is an early Bean Bandit dragster at Paradise Mesa. This dragster was set up to run two engines. Unprecedented at the time, it turned many heads and made lots of headlines. (Courtesy of Ruben Lovato.)

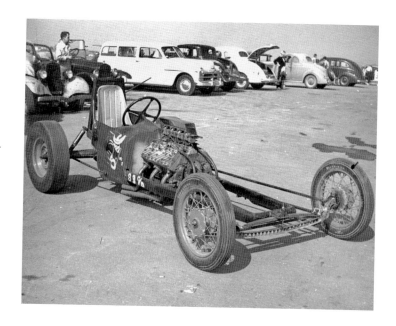

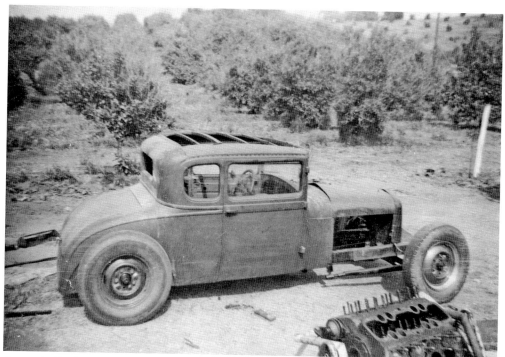

An early Dode Martin car sitting in the orange groves of Fallbrook on his father's ranch in 1949. This A-V8 coupe was run early at Paradise Mesa Strip. Martin later turned to his stripped-down roadster and began his battles with Art Chrisman and the Bean Bandits. (Courtesy of Dode Martin.)

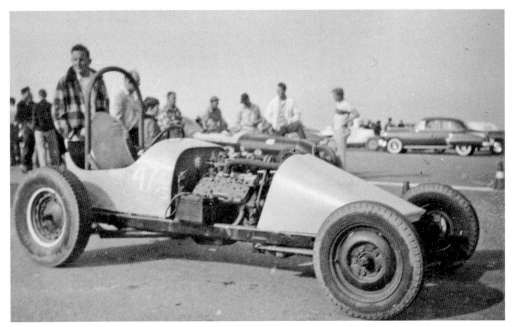

Dode Martin of the Oilers Club stands behind his dragster at the starting line at Paradise Mesa in 1952. Dode would later team up with Jim Nelson, owner of a car-parts store, and begin making dragster chassis. They would become known as the Dragmasters. (Courtesy of Dode Martin.)

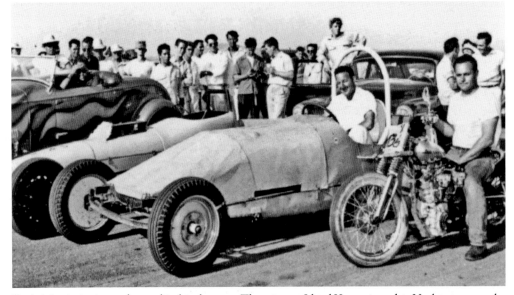

Dode Martin is pictured seated in his dragster. The winner, Lloyd Krant, is on his Harley motorcycle. Dode stated he had the faster speed, but there were no ET (elapsed times) yet: "I was faster, but he was quicker off the line. That's me, always faster, but he got the trophy." On the left is the Bean Bandit roadster that Dode beat to reach the "Top Eliminator" final of the Pacific Southwest Championships in 1953. This image was captured at Paradise Mesa Drag Strip. (Courtesy of Dode Martin.)

BEAN BANDITS IN PARADISE

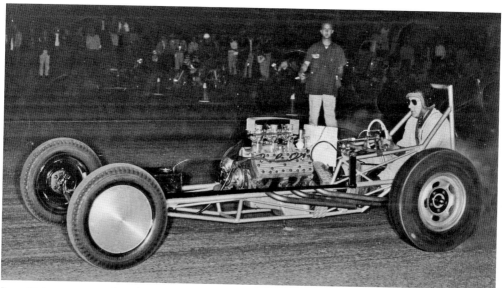

Jerry Baltes is pictured in dragster built by Joaquin Arnett. Baltes sacrificed his daughter's swing set for the chassis. A note attached to this photograph from Baltes read, "The seat was from my wife's dinette set. The helmet is my brothers football helmet. However—The sun glasses are mine. Sun glasses at the nite drags??" (Courtesy of Jerry Baltes.)

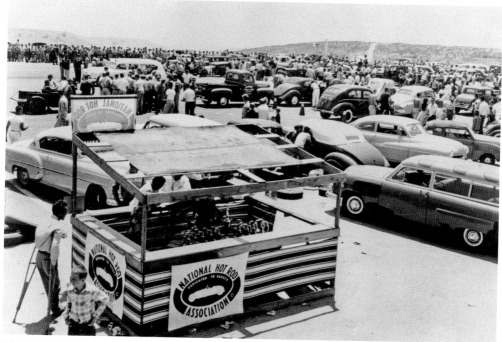

This view of the NHRA booth at Paradise Mesa looks west. A great crowd had come out for this event. This image may have been captured during the 1953 Pacific Regionals sponsored by the NHRA, hence the booth. In the center at the right of the clearing is a Prowler car with the hood up. (Courtesy of the Prowlers.)

SAN DIEGO DRAG RACING AND THE BEAN BANDITS

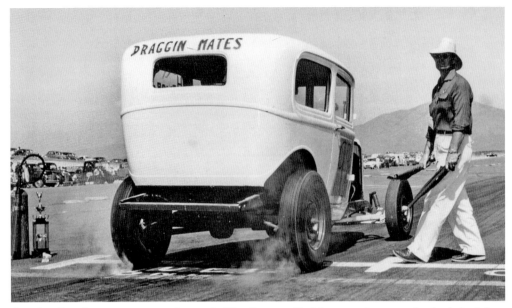

Another Prowler car is getting the sendoff by flagman Red Leggott. Leggott also had the job at Bonneville and would be there some 60 years until his passing in 2015. Notice the trophy sitting next to the fire extinguisher. (Courtesy of the Prowlers.)

Emery Cook is seen here when he ran with the Bean Bandits in front of his house, with the dragster on the trailer. Cook was Joaquin Arnett's brother in law. From left to right are Andrew Ortega, unidentified, Leo Layva (near car), Emery Cook (behind Layva), unidentified, Fred Martinez, Carlos Ramirez, and "Ningy" Ningetta. (Courtesy of the Fred Angelo Bean Bandits Collection.)

BEAN BANDITS IN PARADISE

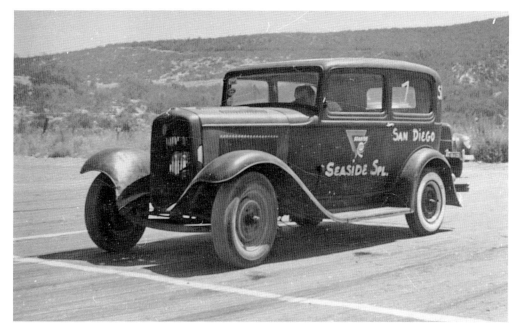

Mike Nagem is ready to take his Seaside Special sedan down the strip. The sedan was more of a workhorse for the Bean Bandits than a racer. It was used to push start the dragsters and transport the club members. But if a car passed specs, there was nothing keeping one from taking it for a run. (Courtesy of Ruben Lovato.)

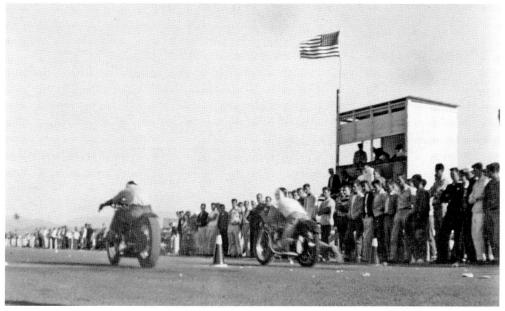

This is the starting line at Paradise Mesa, with two motorcycles taking off. Motorcycles competed against cars in the early days of drag racing and were hard to beat because of the weight to power ratio. It would take time and ingenuity, but Arnett and the Bean Bandits would wrestle that crown from them. (Courtesy of Ruben Lovato.)

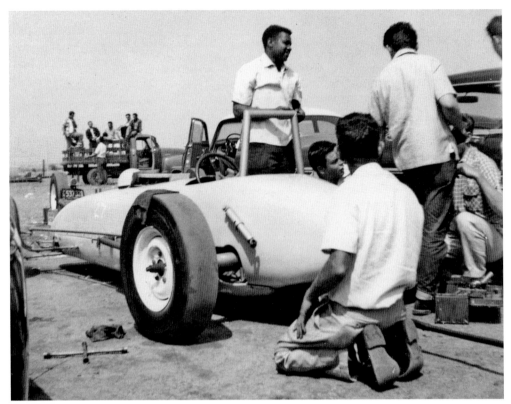

A Bean Bandit dragster is in the pit area, and standing is Harold Miller. Behind the dragster is Arnett, kneeling with his back to the camera is Andrew Ortega, and to his right is Carlos Ramirez. Harold Miller was an early member of the Bean Bandits but was noted for working with several racing teams. (Courtesy of Fred Angelo.)

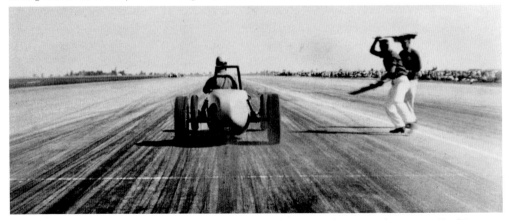

This is a nice shot of the smooth strip Paradise was known to have. In this image, Red Leggott sends off Joaquin Arnett in the Bean Bandit dragster. The Navy built the landing strip during World War II for emergency landing and touch-and-go training. After the war and before the runway became an official drag strip, hot rodders shared the strip with the occasional private plane. (Courtesy of the Prowlers.)

Emery Cook, Arnett's brother-in-law, is pictured with a few of his trophies. Viola Arnett states that Emery knew Joaquin and Joaquin liked him. Noralund, Joaquin's sister, was living with them, and one weekend at the local dance, when it was time to walk home the single men, like clockwork, would come over and politely ask Nora if they could escort her home. She would look at Joaquin and he would give them once over and say no. When Emery asked, Joaquin said "sure," without so much as a glance, to Nora's surprise. (Courtesy of the Cook family.)

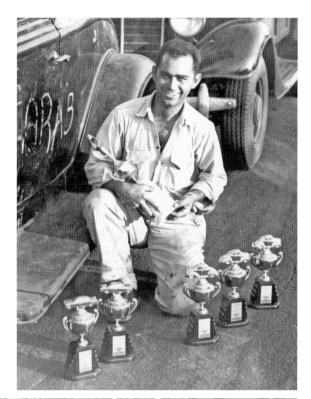

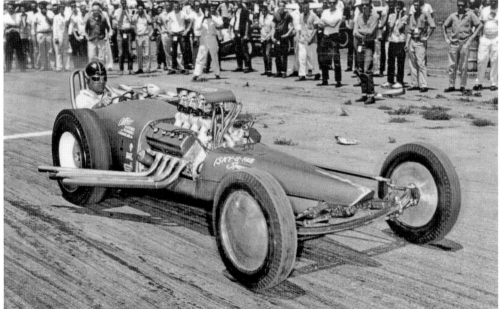

Emery is seen in the famous Cook-Bedwell dragster at Paradise in 1957. This dragster would turn heads in the latter years of Paradise before the strip was closed. Cook would break the quarter-mile record by an astonishing 11 miles per hour. The Cook-Bedwell dragster would usher in the modern era of drag racing. (Courtesy of the Cook family.)

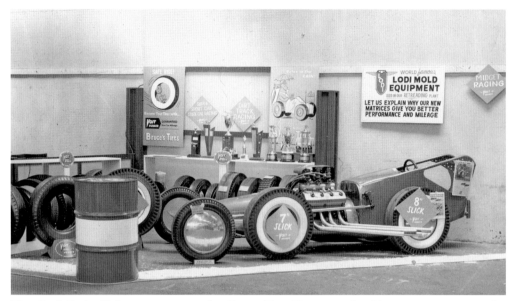

The Cook-Bedwell dragster is pictured at Bruce Tire Shop near San Francisco, promoting the seven and eight-inch slick tires. Tires were always essential, as getting more power out of the engine meant nothing if the power could not find traction. (Courtesy of the Cook family.)

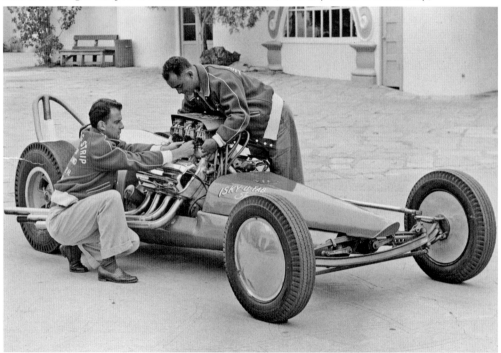

Cliff Bedwell is in front of the dragster as Emery leans over the engine, preparing the dragster for a promotional shoot for Ed "Isky" Iskenderian in Balboa Park in 1957. The Cook-Bedwell ran Iskenderian five-cycle cams, and when the dragster blew past the record, clocking 167 mph, Isky wanted to promote while the irons were hot. (Courtesy of the Cook family.)

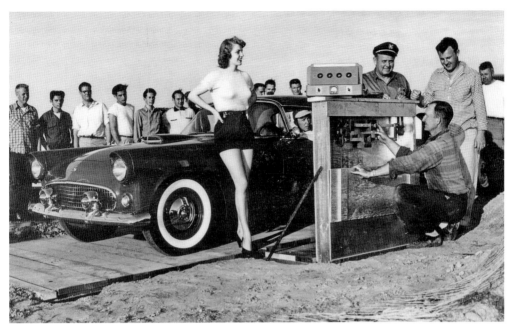

This is the weight scale at Paradise Mesa Drag Strip in 1953. Working the scale is flagman Red Leggott; to his right is Paradise promoter Bob Menard. Over Menard's shoulder is drag racer Bozzy Willis, and wearing the cap is J.O. Crocker. (Courtesy of the Prowlers.)

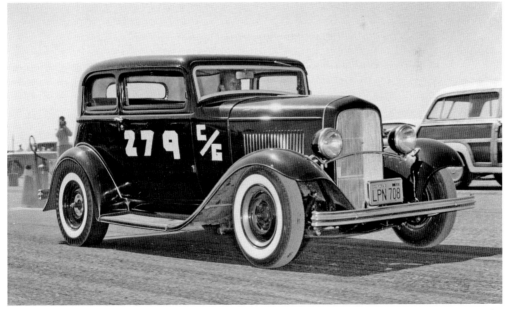

Andy Bekech of the Prowlers takes off at Paradise Mesa in his 1932 Ford Victoria Coupe in 1957. Bekech stated that the car was being used as a chicken coup and was restored by Bob Stewart, the son of Stewart's Speed Shop owner in San Diego, Ed Stewart. According to Andy, when he decided to chop the 1932, he went to Arnett, who did it for a case of beer. The car later graced the cover of *Cars and Craft* magazine. (Courtesy of the Prowlers.)

SAN DIEGO DRAG RACING AND THE BEAN BANDITS

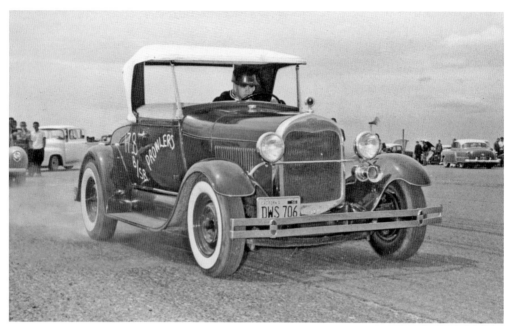

This beautiful Prowler car taking off is Tom Madruga's 1929 Ford roadster with a 327-cubic-inch Corvette engine and a 1939 Ford transmission. Andy Bekech states the car was very fast and never lost a race. Madruga is a retired San Diego County surveyor. (Courtesy of the Prowlers.)

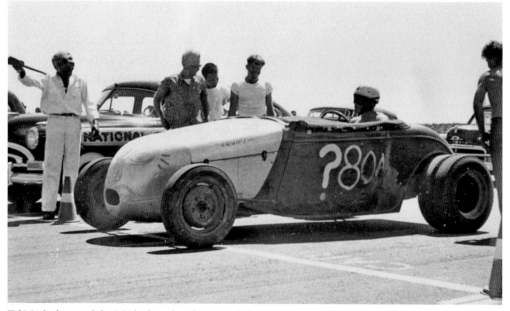

Ed Nicholson, of the Nicholson brothers, and the question-mark car out of Los Angeles are seen here. This roadster ran hard, made the rounds of all the track, and gave the San Diego boys a run for their money—or trophy, that is. There were no money rewards in the early days of drag racing, just trophies and bragging rights. Notice the "dualies," the rear double tires. The Nicholson brothers are trying to get the power to the ground. (Courtesy of Ruben Lovato.)

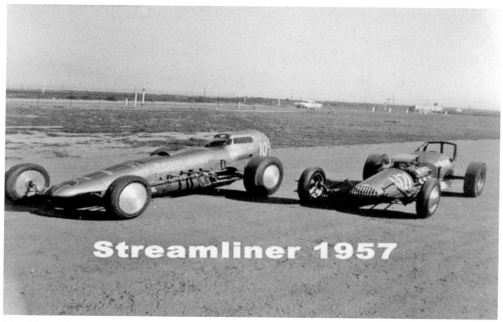

This November 1957 photograph shows the Master Auto Supply dragliner, with its fiberglass body and canopy, alongside the "Two-Thingie" (two engine) dragster. These are innovative works by Dode Martin and Jim Nelson, who would partner to become the Dragmasters, manufacturers of ready-made drag chassis. At the 1957 NHRA Nationals, the dragliner won "Best Engineered." (Courtesy of Dode Martin.)

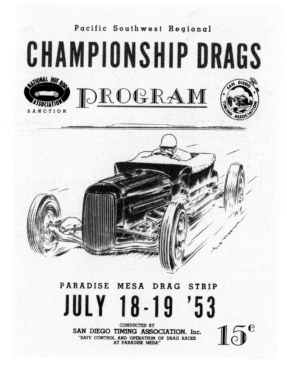

This is the cover of the Pacific Southwest Regional program 1953, a NHRA-sanctioned event. This became a big event in San Diego after the Bean Bandits had beat all comers (350 entrants) earlier in the year at the first nationally sanctioned event by the NHRA at the Pomona Drag Strip. Everyone wanted to see the Bean Bandits, and all drag racers had them in their sights. (Courtesy of the Bean Bandits Collection.)

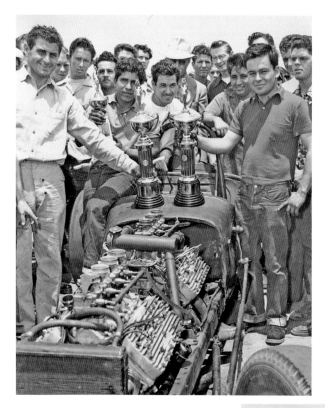

Bean Bandits are seen here after a win, with their twin-engine dragster and trophies in hand. Carlos Ramirez was the primary driver for the Bean Bandits, but Andrew Ortega drove as well. Ortega also worked beside Joaquin Arnett and became a skilled body man. Mike Nagem, as president, was the logistics man but could also wrench. From left to right are Nagem, Ortega, Ramirez, and Arnett. (Courtesy of the NHRA.)

This is the February 1953 cover of *Hot Rod* magazine, one month before their big Pomona win at the first NHRA-sanctioned drag championships. Sitting in the cockpit is Joaquin Arnett, and pushing the dragster, from left to right, are Andrew Ortega, Carlos Ramirez, and Fred Martinez. (Courtesy of the Bean Bandits Collection.)

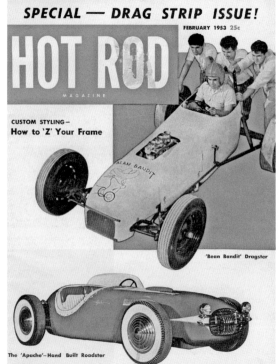

Joaquin Arnett accepts a trophy from Mike Nagem. Behind them is the 1934 coupe that Arnett would chop and section. He would later enter the coupe at the West Coast's Motorama, an exposition of motorized sports, specialized equipment, and ingenuity. Motorman is the forbearer to the annual automotive auto shows of today. (Courtesy of Ruben Lovato.)

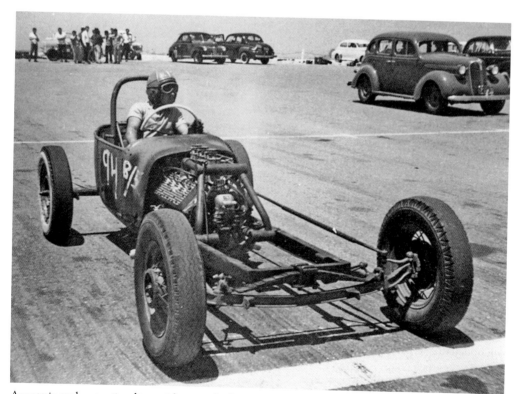

Arnett is at the starting line with an early dragster. It had room in front to make it a twin engine. It looks as if Arnett is wearing an old leather football helmet. If it covered the noggin, it passed inspection back then. (Courtesy of Ruben Lovato.)

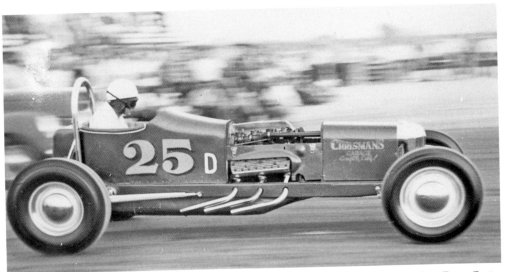

Art Chrisman is pictured in his stretched No. 25 car taking off at Paradise Mesa Drag Strip. Chrisman and the No. 25 would become legends of the sport. Chrisman, out of Compton, California, would routinely make the drive south to San Diego to do battle with the Bean Bandits and Dode Martin, all heavyweights in the field of drag racing. The Bean Bandits would return the favor and travel north to Santa Ana Drag Strip and Pomona. (Courtesy of Ruben Lovato.)

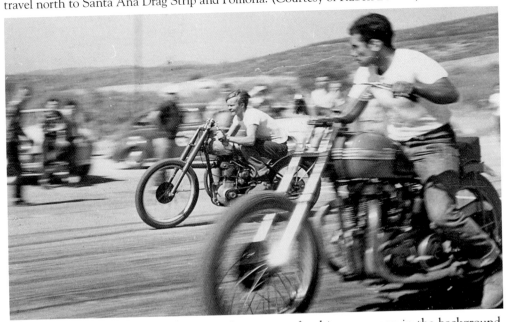

This photograph captures the sheer joy of competing for this young man in the background. Motorcycles were a big part of the drag-racing scene in the early days and inspired the hot rodders to innovate. Dick Kraft began to strip his hot rod to the rails in order to lighten his weight to compete with motorcycles. Arnett stated that as far as he was concerned, Kraft was the godfather of the dragster. It was Kraft who gave Arnett the idea to create his own from the ground up. (Courtesy of Ruben Lovato.)

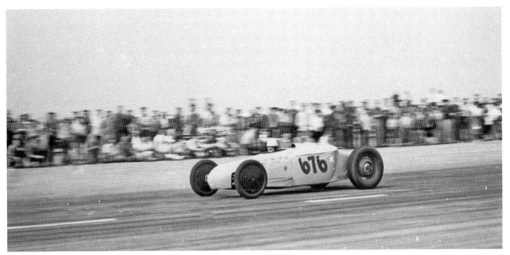

Joaquin Arnett sitting low and leaning into the wind in the 676 Schiefer rear-engine dragster. This beautiful modified dragster would hold several track records and hit a top speed of 156 mph. Only a handful of cars could compete with this dragster. (Courtesy of Ruben Lovato.)

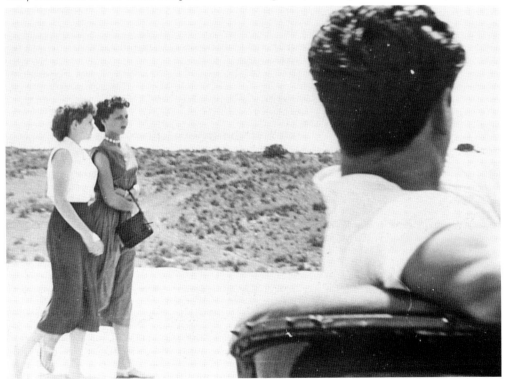

It was not all about the cars at these events. When trying to identify the man in the picture spying the ladies, perhaps a Bean Bandit, Bean Bandit Fred Angelo chimed in and stated he did not know who the man was, but the lady in the white blouse was his wife, Dolores. The man in the picture was later identified as Andrew Ortega. This image was captured in Paradise Mesa sometime in 1952 or 1953. (Courtesy of Ruben Lovato.)

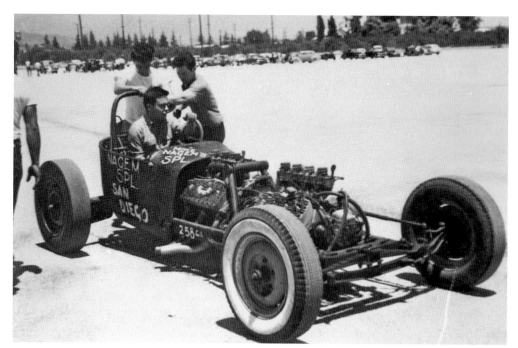

Joaquin Arnett drives Andrew Ortega (left) with Carlos Ramirez. This dragster was built to run in several classes. A Model A body could be placed over and secured with four bolts, and the engines could be removed within minutes and ready to run. It became quite the spectacle in the pits, drawing crowds who wanted to watch the Bean Bandits do their magic. (Courtesy of Ruben Lovato.)

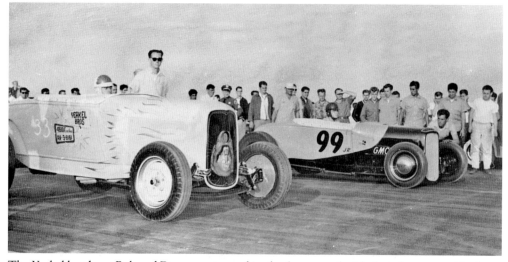

The Yeakel brothers, Bob and Don, are pictured in the foreground with their famous upside-down Von Dutch painted grill, getting ready to race against the 99 roadster of Frank "Ike" Iacano, in Paradise Mesa. The well-known striper Kenny "Von Dutch" Howard accidentally inverted the painting. The Yeakel brothers owned Yeakel Brothers Cadillacs in Los Angeles and ran the lakes with Lou Baney. (Courtesy of Ruben Lovato.)

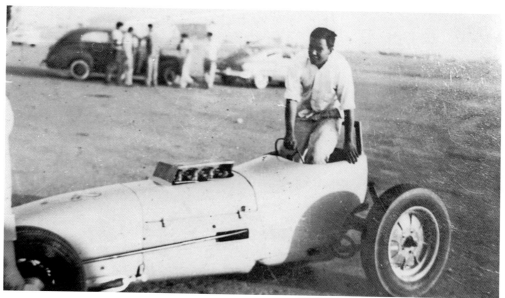

Joaquin Arnett, pictured here in a dragster, ran a Paul Schiefer clutch in his dragsters. In Lodi, California, after a meet with the Bean Bandits, he ran a speed run without changing clutches in high gear only to show the locals the durability of their Schiefer clutch. At the time, stock clutches rarely lasted a few runs. The Bandits had run the same clutch for the past four weekends. Monday morning, Schiefer called Arnett and asked what the heck he had done there, because his phone would not stop ringing. (Courtesy of Ruben Lovato.)

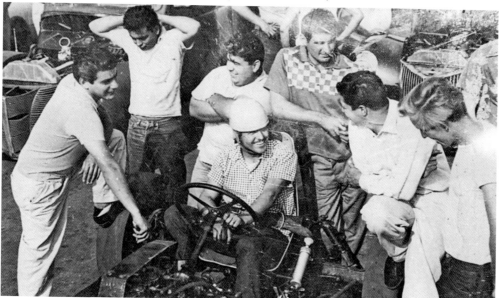

The twin-engine dragster is pictured after a run in the pits. Carlos Ramirez is in the driver's seat. It must have been a good run, because it is smiles all around. From left to right are Albert Colorado, Joaquin Arnett, Charley Ellias, Mike Nagem, unidentified, and Wane Finley. (Courtesy of Ruben Lovato.)

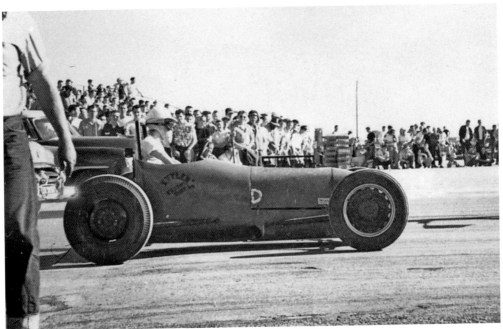

This dragster is from Styler's Custom Shop in San Diego, located on Eighteenth Street and National Avenue in National City. The goggles and scarf is a dead giveaway that he is running nitro. Bean Bandit Robert Martinez was co-owner of the custom shop. (Courtesy of Ruben Lovato.)

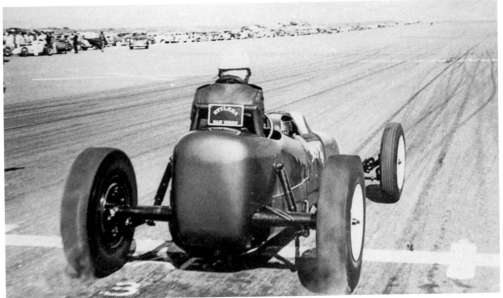

Another Styler's Custom Shop dragster is taking off at Paradise. Styler's Custom Shop was well known to the hot rodders. Styler's work could be seen on many cars of the day and in car magazines such as *Car Craft*, which stated that Styler's was one of the busiest custom shops in the country. Bean Bandit Robert Martinez and Carroll Gentry were co-owners of the shop. (Courtesy of Ruben Lovato.)

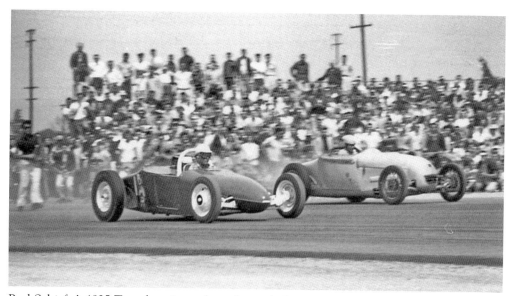

Paul Schiefer's 1925 T roadster is on the right, with the motor in front. There are many stories about this car and how it was lent to Arnett, who turned it into a read engine dragster. The roadster had a top speed of 148 mph and a class record at the lakes. It was also a test vehicle for developing Schiefer's aluminum flywheel, becoming the first product produced by Schiefer Manufacturing Company. Schiefer was inducted in the inaugural class of the International Hall of Fame in 1991. (Courtesy of Ruben Lovato.)

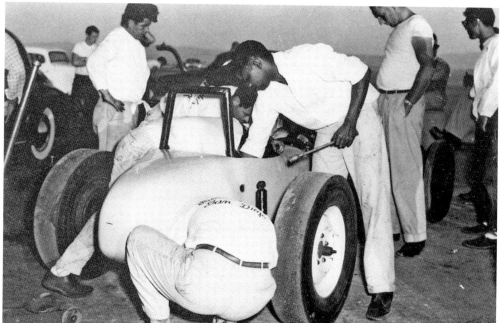

Working on the Bean Bandit dragster are Eddie Espinoza and Harold Miller (with wrench in hand) at Paradise. The Mark II dragster is sporting a sprinter nose at the rear as Joaquin Arnett continued to modify, always looking to go faster. (Courtesy of Ruben Lovato.)

SAN DIEGO DRAG RACING AND THE BEAN BANDITS

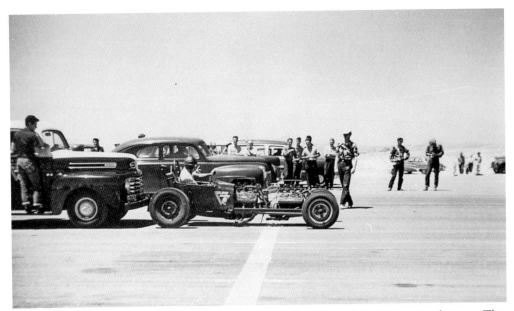

Mike Nagam is using his Seaside Service Station truck to start the twin-engine dragster. This dragster was built for the purpose of running in several classes in order to accumulate as many points for the Bean Bandits. A Tudor Model A body could be bolted on in a matter of minutes, and it could run in six classes. (Courtesy of Ruben Lovato.)

At the line is Joaquin Arnett's personal car, the 1934 coupe before it was chopped and sectioned and became the iconic car that is today. Arnett began work on this coupe in late 1949. In 1951, Arnett would win a craftsman award for his work at the Motorama Exhibition in Los Angeles. The truck he is lined up against belongs to Stewart's Speed Shop. (Courtesy of Ruben Lovato.)

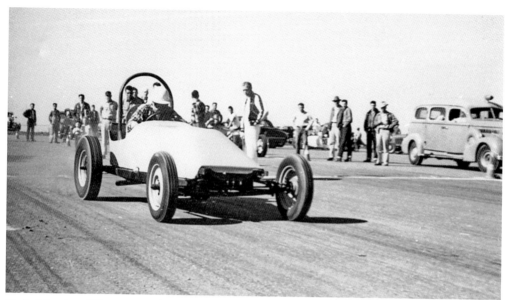

Dode Martin, of Dragmaster fame, is shown here leaning into the wind as he takes off from the starting line at Paradise Mesa. Note the ambulance always at the ready. Martin, like many hot rodders, was a returning veteran. He had shipped out just in time to find himself at the Battle of the Bulge. Martin was inducted into the International Hall of Fame in 1998. (Courtesy of Ruben Lovato.)

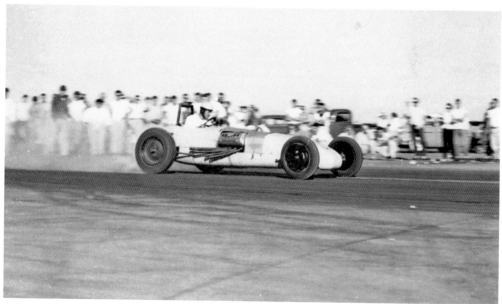

Carlos Ramirez, leaning into the wind, takes off, with tires smoking in the Bean Bandit dragster at Paradise. The Ardun-Merc Mark II was built in time for the first NHRA national event at Pomona in 1953. When the famed Mark I lost in the first heat at the event, according to Pat Durant, the Bean Bandits all looked at each other a little worried, but the Mark II, Durant stated, "took us all the way." (Courtesy of Ruben Lovato.)

SAN DIEGO DRAG RACING AND THE BEAN BANDITS

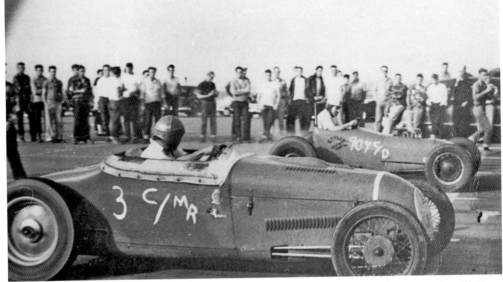

Paul Schiefer in the foreground staring down the Styler's Custom Shop driver at take-off. Note the Schiefer spindle front wheels. Arnett would one day walk into Schiefer's Shop and spy the spindle wheels and asked if he could have them. Schiefer obliged, and soon one of the Bean Bandits' cars was running down the strip with them. (Courtesy of Ruben Lovato.)

This is the first Bean Bandit full-body dragster built strictly for drag racing. Arnett kept the size and weight to a minimum. The wheel base is 84 inches, weighs 1,325 pounds, and is powered by a 275-cubic-inch Mercury engine. Arnett's mastery of metalworking is apparent on this little dragster. By 1953, it had held track records at all the California drag strips at one time or another. This photograph was taken at Paradise Mesa. (Courtesy of Ruben Lovato.)

BEAN BANDITS IN PARADISE

Motorcyclists pose for a nice shot. Pat Durrant of the Bean Bandits and longtime master piston grinder for Schneider Racing Cams states that Art Chrisman gets credit for taking the track record from the motorcycles, but he says it was the Bean Bandits. That should get the debate going. (Courtesy of Ruben Lovato.)

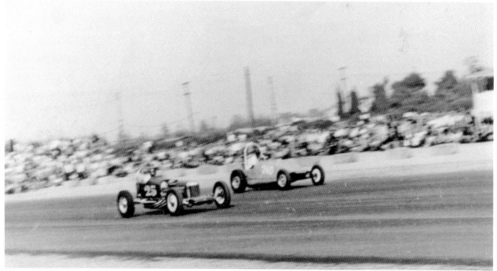

Dode Martin races against Art Chrisman, in the No. 25, at Paradise. These two future Hall of Famers are going toe to toe. As the story goes, Martin was tired of always losing by a nose to Chrisman, so he set his carburetors for one last burst when he needed it. As they came to the finish line, Martin dumped the fuel through his carbs and got the burst he needed, beating a visibly upset Chrisman, Martin burned up his engine in the process, but he got the win. He said he never told Chrisman how he beat him. (Courtesy of Dode Martin.)

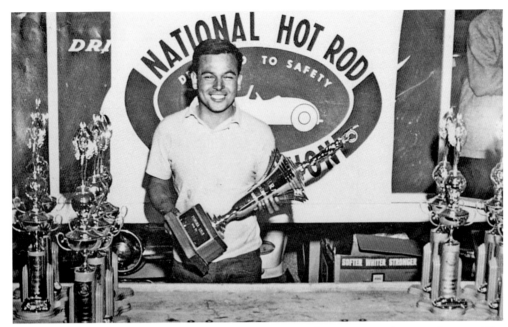

Joaquin Arnett holds the winner's trophy at the NHRA first sanctioned national event. The importance of this photograph is that it was the first time the NHRA banner was displayed. This is the first image of this iconic emblem and was requested by the Smithsonian Automotive Museum. (Courtesy of Ruben Lovato.)

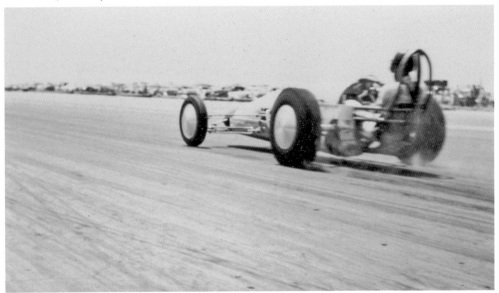

Jim Nelson is taking off in the dragliner. Nelson was a San Diego Timing Association (SDTA) official and technical advisor for NHRA, as well as a hot rodder and drag racer. He would eventually team up with Dode Martin to form Dragmasters, a manufacturing company of drag-racing chassis, in Carlsbad, California. Nelson won the NHRA Winter Nationals in 1962 and was inducted into the inaugural International Drag Racing Hall of Fame in 1991. (Courtesy of Dode Martin.)

BEAN BANDITS IN PARADISE

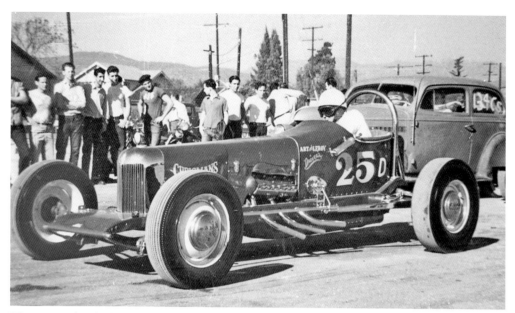

This is another look at Chrisman's No. 25. A quick look at the track records in the early years of drag racing shows Chrisman and the Bean Bandits in a back-and-forth battle. Once on the way to Bakersfield, Fred Angelo recalled, the Bean Bandits in the old Hudson overheated, and Chrisman just drove by with a wave. They met Chrisman in the Top Eliminator, and Arnett said, " 'Fred put in the pop.' It was the first time I had heard that word for the nitro, and we got him." (Courtesy of Ruben Lovato.)

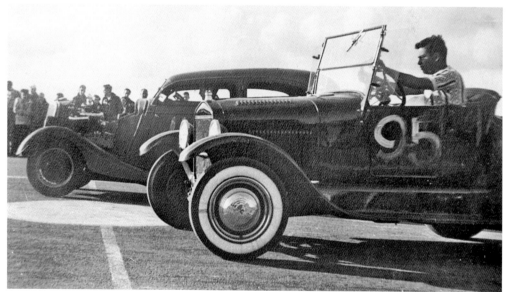

Joaquin Arnett is in his Model A roadster at the starting line. Although this chopped sedan seems to have the jump on him, Arnett must have been confident of victory because he left the windshield up. He said when he really needed to "go" in this car he would dropped the windshield and pick up another four or five mph. (Courtesy of Ruben Lovato.)

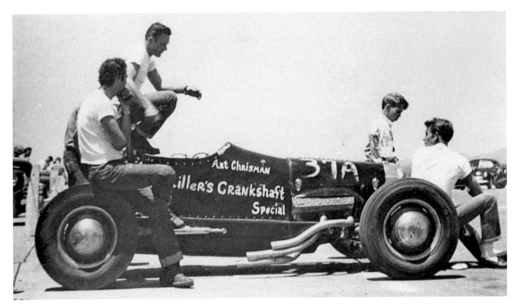

Art Chrisman climbs into his Miller Crankshaft Special before he had lengthened it. Pat Durant tells the story of the Bean Bandits dragster breaking down at Santa Ana Dragstrip and Chrisman handing them the keys to his garage in Compton and saying to just lock it up when they were done. The Bean Bandits worked all night and were ready to compete the next day. "He was a good guy," Durant said. (Courtesy of Ruben Lovato.)

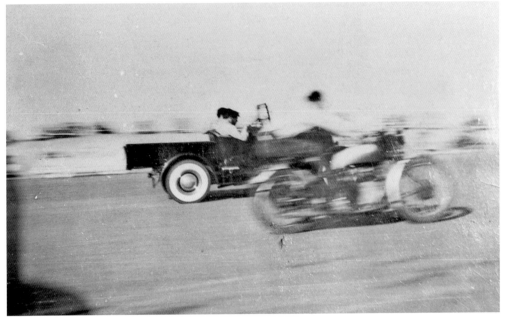

A Bean Bandit, probably Arnett (it is his Model A modified pickup), races a motorcycle. Arnett was constantly salvaging and building cars; if not for himself, then for others. Any car Joaquin built would find its way to the drag strip. He stated that he never owned a car longer than a year and half. (Courtesy of Ruben Lovato.)

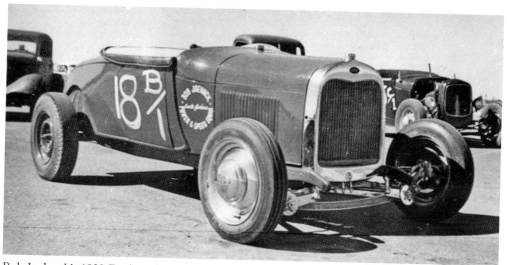

Bob Joehnck's 1929 Ford roadster is pictured here. This car was involved in the first organized drag races. After the war, Joehnck and his Whistler Car Club members began racing on a service road of the abandoned military airport Goleta Airport in Santa Barbara. By 1949, the Sunday after-church races were getting crowded, and organization was needed. The result was the Santa Barbara Acceleration Association, which then acquired insurance to assuage the property manager, and as they say, the rest is history. (Courtesy of Ruben Lovato.)

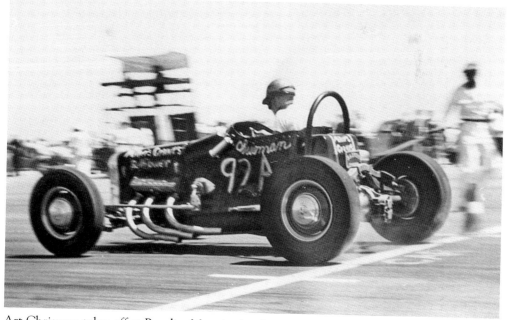

Art Chrisman takes off at Paradise Mesa in the short version of the No. 25 car. Chrisman, his brother Lloyd, and Uncle Jack would become a force in the drag-racing world, building beautifully designed, fast, record-setting dragsters and roadsters out of their garage in Compton, California. Chrisman was inducted into the inaugural International Drag Racing Hall of Fame in 1991. (Courtesy of Ruben Lovato.)

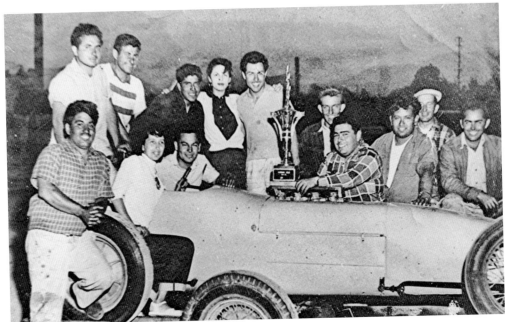

The Bean Bandits celebrate the big victory at the first NHRA Championship, held at the Pomona Drag Strip in Pomona, California. A total of 350 entrants competed in this seminal event, and an estimated 20,000 fans were in attendance. Pictured from left to right are (front left) Bill Galvin, Viola (or "Vi") and Joaquin Arnett; (back row) Cupe Torado, Mike Nagem, Andrew Ortega, Rose and Carlos Ramirez, Wayne Finley, Charles Elias (hand on trophy), Pat Durant, Jimmy Pappas, and Emery Cook. (Courtesy of Ruben Lovato.)

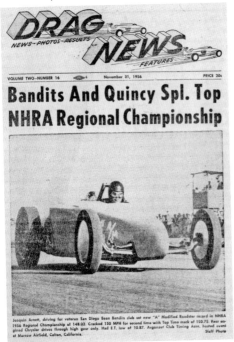

DRAG NEWS
NEWS—PHOTOS—RESULTS
FEATURES

VOLUME TWO—NUMBER 16 November 31, 1956 PRICE 20¢

Bandits And Quincy Spl. Top NHRA Regional Championship

Joaquin Arnett, driving for veteran San Diego Bean Bandits club set new "A" Modified Roadster record in NHRA 1956 Regional Championship of 148.02. Cracked 150 MPH for second time with Top Time mark of 150.75. Rear engined Chrysler drives through high gear only. Had E.T. low of 10.87. Argonaut Club Timing Assn. hosted event at Morrow Airfield, Colton, California.
Staff Photo

On this *Drag News* cover from November 1956, the Bean Bandits surpass the 150 mph for the second time at the Southern California Regional Championship at Morrow Airfield in Colton, California. The Joaquin Arnett built rear-engine roadster with Arnett driving "cracked the 150 barrier. Once considered impossible but once again accomplished. This time by one of the oldest groups in drag racing. Their time–150.75." (Courtesy of the Bean Bandits Collection.)

BEAN BANDITS IN PARADISE

The Bean Bandits women had their uniforms as well. Second from left is Viola "Vi" Arnett in her "pullover" pants and Bean Bandit blouse. Vi was more than just a cheerleader for Joaquin and the Bean Bandits. She could be found many nights cleaning engine parts around the kitchen table. The men's peasant outfits were a gift from a Mexican village where news of the Bean Bandits' success had made them legends. (Courtesy of Ruben Lovato.)

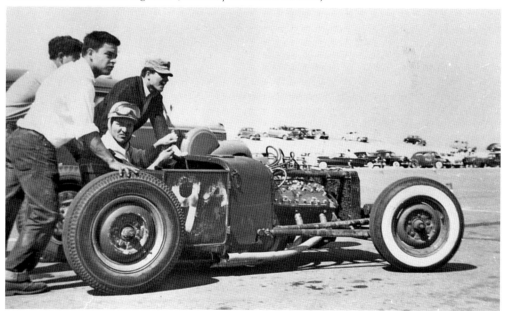

The Bean Bandits are pictured in Paradise Mesa in August 1951 with an early Merc-powered dragster. Carlos Ramirez is in the driver's seat. Joaquin Arnett wears a white shirt. Partially hidden behind Arnett is Andrew Ortega, and Karl Kirk wears the cap. Arnett always liked this photograph of Ramirez. He had no fear, according to Arnett: "He would ask, 'Joaq, is it ok?' after I had looked the car over, and if I said yes, he would say, 'Okay, let's go,' and that was it." (Courtesy of Ruben Lovato.)

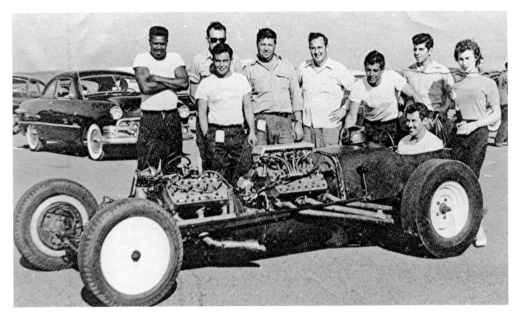

The twin-engine dragster is at Paradise Mesa in June 1952. This dragster is considered to be the first to have the driver behind the rear axle. It was said to look as if the driver were in a "slingshot getting ready to be shot down the strip." Later in the decade and into the mid-1960s, this became the model for the majority of dragsters. From left to right are Harold Miller, John Wright, Joaquin Arnett, unidentified (behind Arnett), John Burke, Eddie Espinoza, Leroy Mittar, an unidentified trophy girl, and Carlos Ramirez (sitting in car). (Courtesy of Ruben Lovato.)

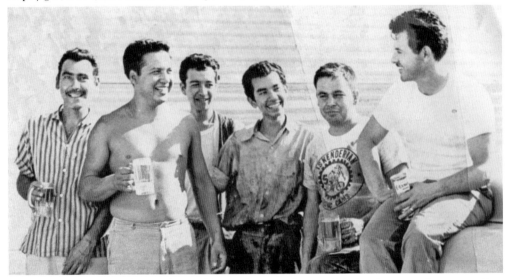

This photograph was taken in front of Arnett's repair shop on Market Street in downtown San Diego. Carlos Ramirez, sitting on his car, has stopped by after work to say hello. It seems someone brought beer for the occasion. From left to right are Albert Caldorada Ruben Lovato, Moe ?, Leroy Guerrero, Joaquin Arnett (in his Iskenderian 5-cycle T-shirt), and Ramirez. (Courtesy of Ruben Lovato.)

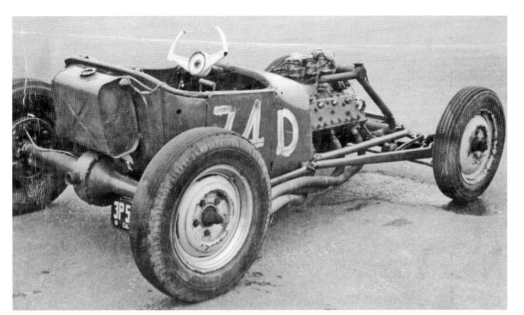

This is the first Bean Bandits dragster. According to George Martinez, this dragster was all iron, put together from salvaged parts. As a young boy, Joaquin Arnett lived across the alley from Edgar's Auto Body and Welding Shop. The shop specialized in building armor trucks and hearses. One of his first jobs was cleaning the shop at the end of the day. (Courtesy of Ruben Lovato.)

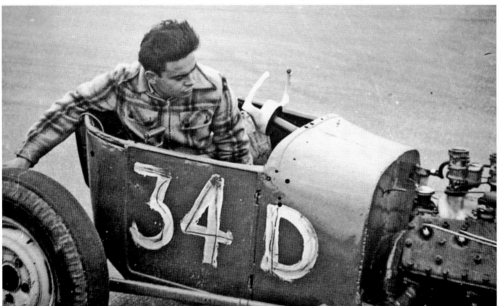

Here, Joaquin Arnett is pictured in this early dragster, preparing it for a run at Paradise. Arnett did his own bodywork, having learned from some of first "body men." Arnett said that these "body men" back then (around 1920) stated if someone needed a fender, it had to come from Michigan, and that could take weeks. Guys started teaching themselves how to do metalworking. Later, some of these guys worked at Edgar's, and he learned from them. (Courtesy of Ruben Lovato.)

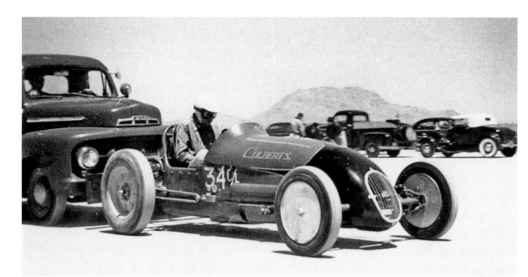

Jim Culbert ran this modified sprint car at Paradise and on the lakes. Here he is getting a push to start his run at the lakes. He was the first driver to exceed 200 mph in a sprint car and would became a leader in sprint car manufacturing. He was inducted into the National Sprint Car Hall of Fame in 2004. (Courtesy of Ruben Lovato.)

Mike Nagem works on the dragster at the Pomona drag strip during the NHRA first national event won by the Bean Bandits. Nagem owned Seaside Service Station in Ocean Beach, where the Bean Bandits would meet and hang out. A young future drag racing Hall of Famer would work there, by the name of Jerry Baltes. (Courtesy of Ruben Lovato.)

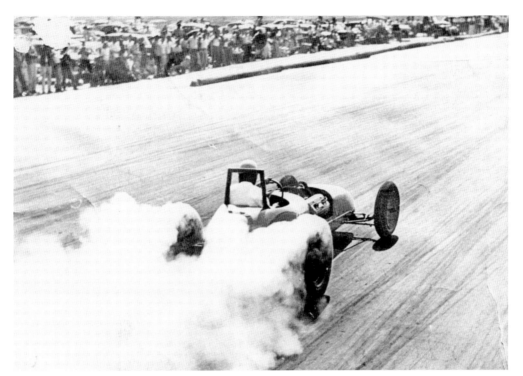

Joaquin Arnett turns a 150 at Santa Ana Drag Strip in 1954, with his Ardun engine. The Ardun Overhead Valve (OHV) was designed by Zora Arkus-Duntov, who would come to be called the "Father of the Corvette." After a race, Arkus-Duntov told Arnett he had some Ardun heads on the cheap in his Texas factory yard. Arnett, Ruben Lovato, and Robert "Mertz" Mertren went straight from the race in California to Texas to retrieve the much-coveted Ardun heads. (Courtesy of Ruben Lovato.)

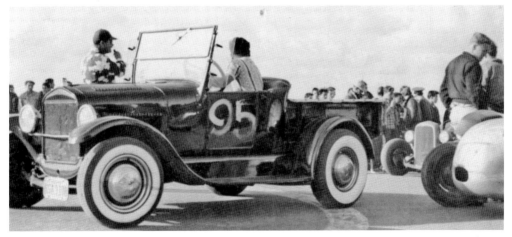

Joaquin Arnett sits in his Model A, looking for his next race. Arnett was a pioneer of nitromethane, which gave him an edge. This knowledge of nitro, coupled with his engine skills and his ability to shape metal, made Arnett and the Bean Bandits a formidable match at the drag strips. (Courtesy of Ruben Lovato.)

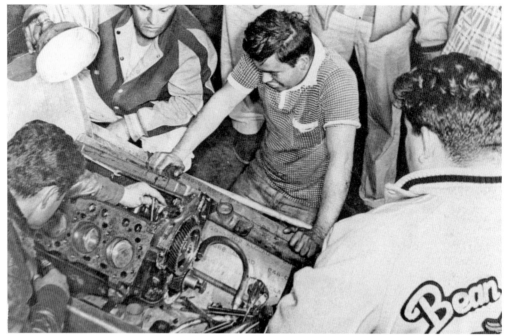

Joaquin Arnett is pictured problem solving. Arnett was an oiler during the war, keeping the engines running aboard the Maritime ship and seeing action at Iwo Jima and Saipan. Arnett stated several times about engines that he would "go inside them" to solve problems. His experience with huge engines as an oiler no doubt gave him what nowadays might be considered a 3-D vision of an engine. (Courtesy of Ruben Lovato.)

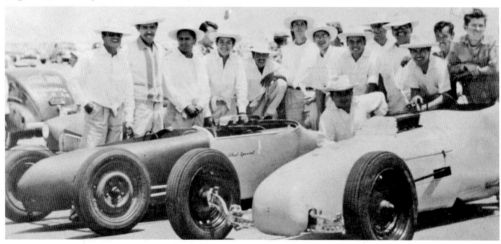

Bean Bandits are seen here in their peasant outfits after a win. Andy Bekech said that, in those days, "the Caucasians did not really mix with the Mexicans, but Joaquin was such a special guy with a lot of charm that he was always inviting others over to share their food. All the Bean Bandits were like that, and when they would have the tequila, man, it became a party, and those guys liked to party. Joaquin did a whole lot in breaking down those barriers between the groups. A real special guy." (Courtesy of Ruben Lovato.)

BEAN BANDITS IN PARADISE

A mainstay at Paradise Mesa Strip, crewing for many teams, Harold Miller looks on as Carlos Ramirez buckles up. The Bean Bandits were, in one aspect, like all other car clubs, which were formed by guys who hung out together. However, the Bean Bandits were unique in that they were a multiracial and multicultural car club. (Courtesy of Ruben Lovato.)

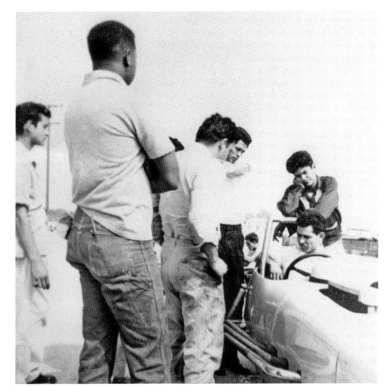

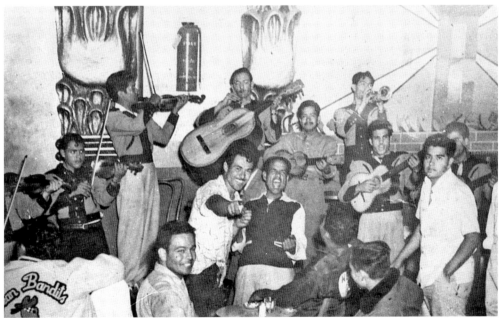

The Bean Bandits are at play in Tijuana. Seated at left is Joaquin Arnett, Carlos Ramirez is pointing toward the camera, and to his left, belting out a good one, is Leo Layva. The esteemed Motorsport journalist and San Diegan Johnny McDonald wrote of the Bean Bandits that they were more than a car club or racing team—"they were family." (Courtesy of Ruben Lovato.)

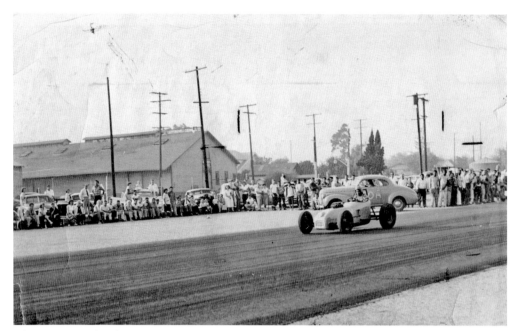

The Bean Bandits dragster is pictured at the Pomona Drag Strip. Although Joaquin Arnett is behind the wheel for this run, the primary Bean Bandits driver was Carlos Ramirez. Andrew Ortega also drove for the club. In 1953, about the time of this photograph, the Bean Bandits held the Pomona Drag Strip record of 134.32 mph. More than likely, this is a speed run. (Courtesy of Ruben Lovato.)

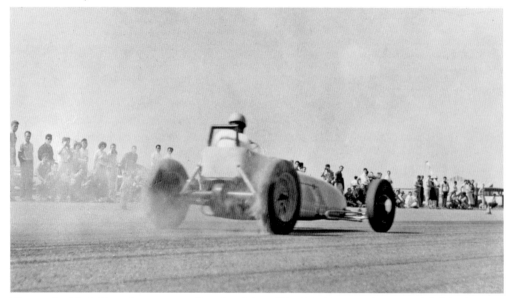

This is the Mark II smoking tires at Paradise Mesa. The Mark II was the second full-body Bean Bandits dragster. By building the Mark II with a longer wheel base and more overall weight located at the rear than its predecessor, the Mark II had better traction and could get off the line quicker. (Courtesy of Ruben Lovato.)

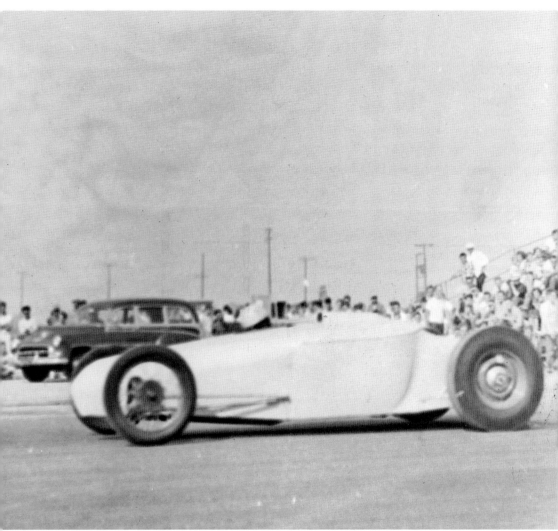

Seen here is the Schiefer/Bean Bandits rear-engine dragster. This car was owned by Paul Schiefer and lent to Joaquin Arnett. The Bean Bandits' cars were a testbed for Schiefer and his clutches. According to Pat Durant, Arnett asked Schiefer if he could "make some changes" to the front-engine roadster, and Schiefer agreed. Arnett then proceeded to modify it into a rear-engine dragster, much to the chagrin of Schiefer. (Courtesy of Ruben Lovato.)

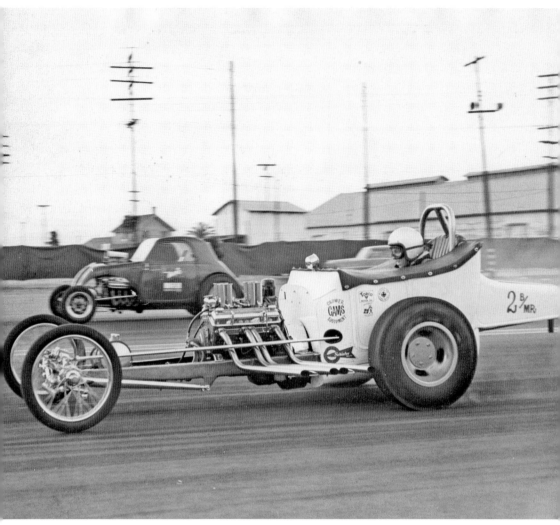

Pictured here in his B-Modified roadster, Jess Van Deventer got his start in 1957 at Paradise Mesa Drag strip running a 1934 Ford with a Buick V-8. In 1962, he would win the NHRA World Championship, defeating the Dragmasters Dart of fellow San Diegans Jim Nelson and Dode Martin. Van Deventer was inducted into the International Drag Racing Hall of Fame in 2015. (Courtesy of Jess Van Deventer.)

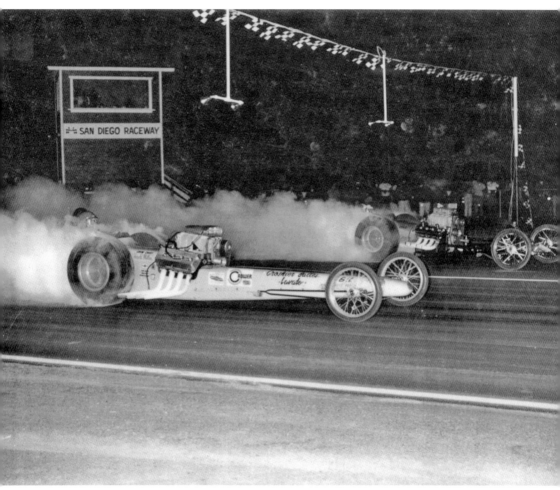

Jerry Baltes sits in the Crower-Baltes-Lavato. In 1951, Baltes began racing at the age of 16 at Paradise Mesa Drag Strip, running a B-Stock sedan. In 1956, Baltes had his first dragster built by Joaquin Arnett. In 1964, Baltes won the World Series of Drag Racing at Cordova and finished the years No. 2 in the NHRA World Points Race. He was inducted in to the International Drag Racing Hall of Fame in 2002. (Courtesy of Jerry Baltes.)

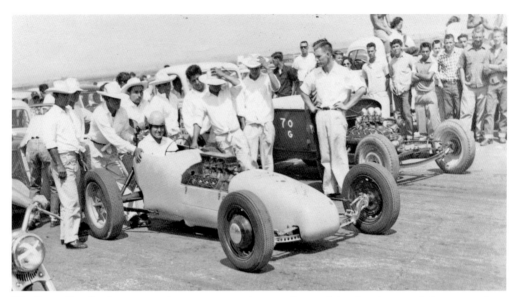

The Bean Bandits have a good time wearing their uniform of the day: hats and shirts sent from Mexico. There were no buttons on those shirts; as Arnett stated, "You had to tie them." The Bandits were always having fun. For the most part, they were all childhood friends. They had gone off to war together, ate together, drank together, and raced together. (Courtesy of Fred Angelo.)

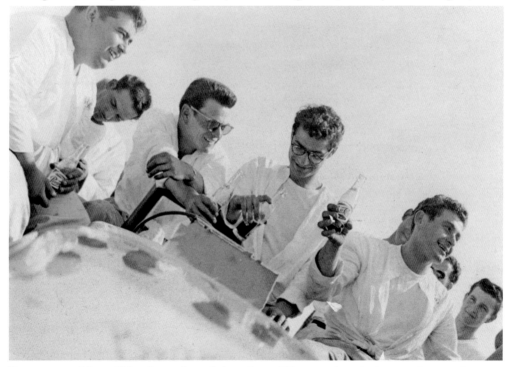

Pepsi, anyone? It is all laughs and good times here. The crew is enjoying another good run at Paradise Mesa Drag Strip. From left to right are Charlie Elias, Leo Layva, "Ningy" Ningetta, George Nagem, and Mike Nagem. (Courtesy of Fred Angelo.)

BEAN BANDITS IN PARADISE

Joaquin Arnett is checking out the Mark I dragster on trailer in 1955. Fred Angelo claimed that the Bean Bandits took turns using tow vehicles. One time, it would be Mel's Cadillac, and another time, it was Angelo's Oldsmobile or Arnett's Hudson, and they shared driving duties as well, with Arnett keeping the peace in the sometimes-crowded cars. From left to right Harold Miller, unidentified, Eddie Espinosa, Joaquin Arnett, and Fred Angelo. (Courtesy of Fred Angelo.)

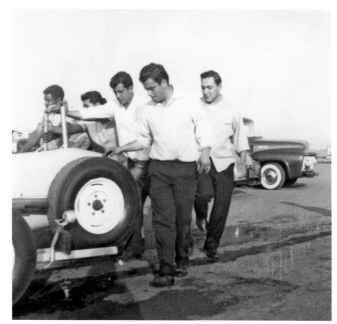

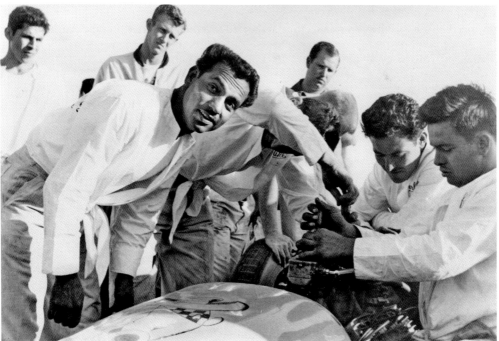

From left to right, Leo Layva (looking at the camera) makes sure he is in the shot as Mike Nagem (with his arm up), Carlos Ramirez, and Joaquin Arnett make some adjustments. The Bandits were known to invite kids who were watching them work in the pits to lend a helping hand; perhaps to help load or unload the cars from the trailer. Afterwards, they would tell the kids to help themselves to a coke and a tamale, which were brought in for the day to share with visitors and guests. (Courtesy of Fred Angelo.)

The Bean Bandits Mark I dragster is in the water. "One of the Original 'Dragsters,'" according to *Hot Rod* magazine's February 1953 issue, this speedy machine holds many Southern California acceleration records. The Bean Bandits' specs are laid out, along with a "cutaway" illustration

showing Arnett's craftsmanship and ingenuity. The following month, Arnett and the Bean Bandits would win the first sanctioned NHRA event at Pomona and enter into drag-racing folklore. (Courtesy of Ruben Lovato.)

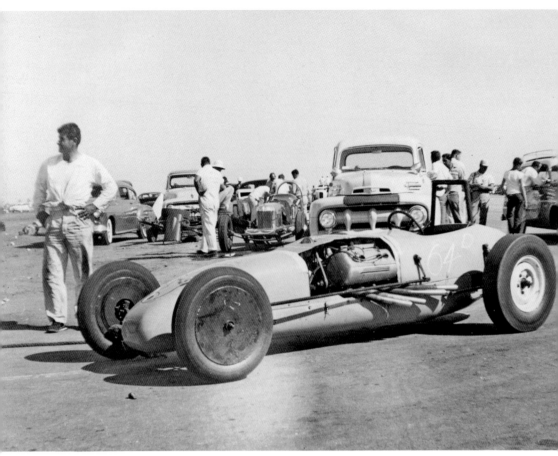

Mike Nagem and a Mark II dragster are pictured at Paradise Mesa Drag Strip. Nagem was instrumental in getting Paradise Mesa Drag Strip off the ground, holding a meeting at his Seaside Service Station, which was attended by some 100 hot rodders. Among them that day was car dealership owner and hot rodder Fred Davies. Davies knew the woman, a Miss Adams, who owned the land on which the government had used for an emergency land strip during the war. (Courtesy of Ruben Lovato.)

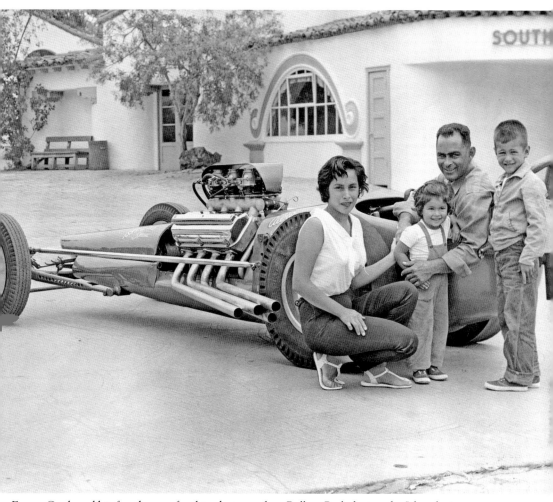

Emery Cook and his family pose for this photograph at Balboa Park during the Iskenderian promo shoot with the Isky U-Fab Special. Cook held the last track record at Paradise Mesa Drag Strip and, as a truck driver working for a construction company, he would pass over the runway one last time depositing the dirt that would forever bury Paradise. Pictured here from left to right are Noralund, Orlean, Emery, and Henry. (Courtesy of the Cook family.)

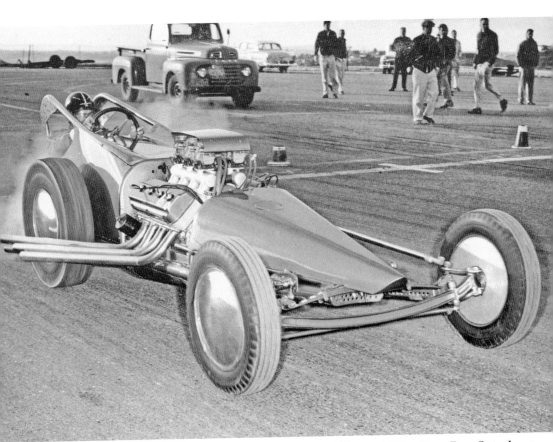

Emery Cook is seen here in the Cook-Bedwell dragster. In February 1957 at Lions Drag Strip, Long Beach, California, Cook drove the Chrysler-powered dragster to a record-breaking speed of 166.97 mph. The 354-hemi engine was built by Bruce Crower using his U-Fab duel log manifold topped with six Stromberg carburetors. A twin-disc Schiefer clutch hooked the power drive directly to the rear axle. Cook was inducted into the inaugural International Drag Racing Hall of Fame in 1991. (Courtesy of the Cook family.)

BEAN BANDITS IN PARADISE

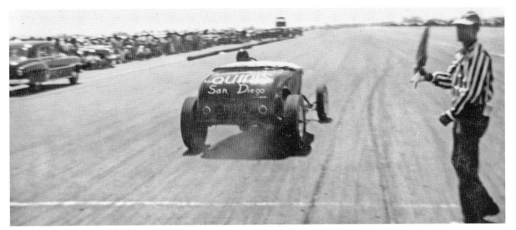

Pictured is a Quints roadster at Paradise. After Emery Cook left the Bean Bandits, he began driving for the Quints brothers. Not long after, Cook found a dragster for sale and went to auto body shop owner Cliff Bedwell to see if he would be interested in putting up some of the money for the Scott Fenn chassis. Bedwell agreed to it. (Courtesy of Ruben Lovato.)

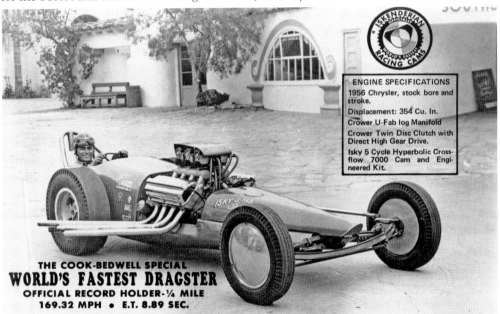

This ad for Ed Iskenderian's Cook-Bedwell, taken at Balboa Park in San Diego, California, in 1957, touts the "5 Cycle Hyperbolic Cross-flow 7000 [rpm] Cam." The Cook-Bedwell had smashed the .25-mile record by more than 11 mph, an unheard-of jump in speed. Iskenderian in the middle of the cam wars did not hesitate to take advantage of the opportunity to promote his mythical cam. (Courtesy of the Cook family.)

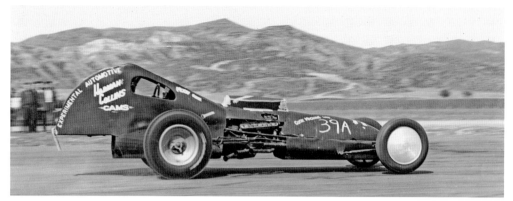

Cook-Bedwell is seen here with the Fenn chassis before modification. The canopy would be removed, and Joaquin Arnett helped his brother-in-law Emery Cook with chassis and engine work. However, the Bean Bandits' Chrysler Hemi was too much for this chassis, and Bruce Crower would come in to help Cook and Bedwell rebuild the dragster. Here, the Fenn dragster advertises the Harmon Collin Cams. Bruce Crower would be inducted into the International Drag Racing Hall of Fame in 1993. (Courtesy of the Cook family.)

Emery Cook works in Burners' Auto Body Shop. The garage was home to two future Hall of Famers: Cook and Arnett. Cook told the story of the beat cop making his rounds at Burners', eyeing not only Cook's work but also the crap game in the corner. The beat cop said his neighborly goodbye to Cook, only to return with a paddy wagon. (Courtesy of the Cook family.)

BEAN BANDITS IN PARADISE

Emery Cook is at Lions Dragstrip receiving his 150 MPH Club jacket. He is seated in the Red Henslee–Emery Cook rear-end roadster first modified by Joaquin Arnett, the famous Paul Schiefer roadster. Schiefer took back the roadster from Arnett and sold it to Henslee, who first partnered with Holly Hedrich, and then with Emery Cook. In 1956, the Henslee-Cook roadster would set the drag racing record at 157.15 mph. (Courtesy of the Cook family.)

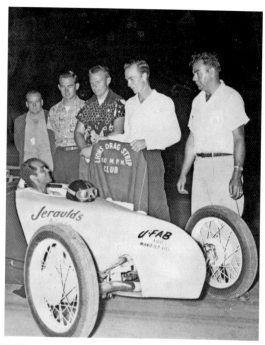

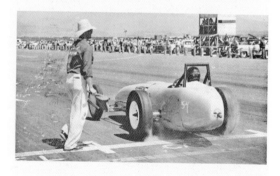

PARADISE MESA AIRSTRIP – SEPT. 23, 1956

CONDUCTED BY

SAN DIEGO TIMING ASSOCIATION

"SAFE PROMOTION AND CONTROL OF DRAG RACES ON PARADISE MESA AIR STRIP"

This is the program for a benefit drag-racing presentation for the United Fund Drive held at Paradise Mesa Drag Strip. In just five years, from the first drag race at Paradise in 1951 to 1956, the SDTA and hot rod clubs like the Prowlers had changed how communities perceived their car culture. (Courtesy of the Prowlers.)

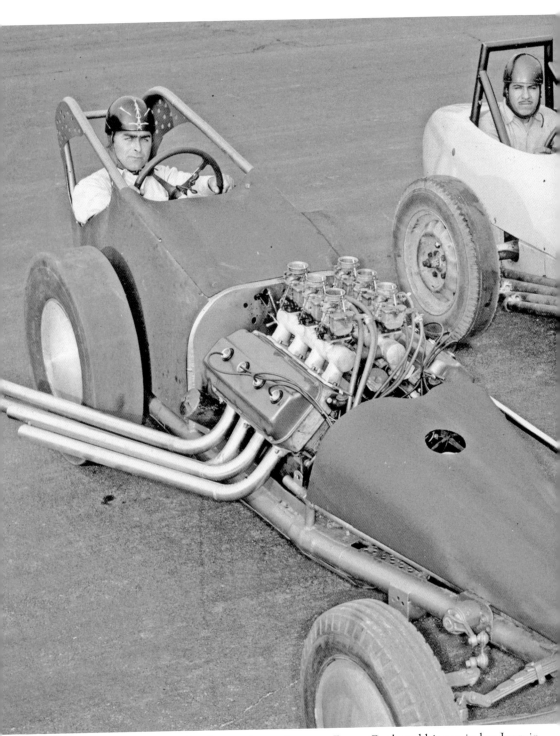

This is a promotional shot for the match race between Emery Cook and his son-in-law Joaquin Arnett and the Bean Bandits. This match race for the United Fund Drive would match the Cook-Bedwell dragster at the cusp of its fame. Six months from the date of this match race, Cook would

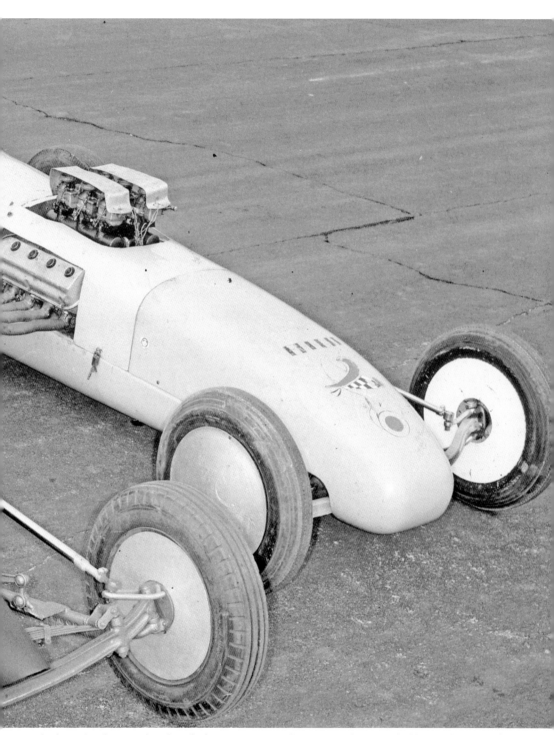

smash the .25-mile record and push drag racing into the nitromethane-fueled banned era. With the ban in place, Arnett and the Bean Bandits called it quits to raise their families. (Courtesy of the Cook family.)

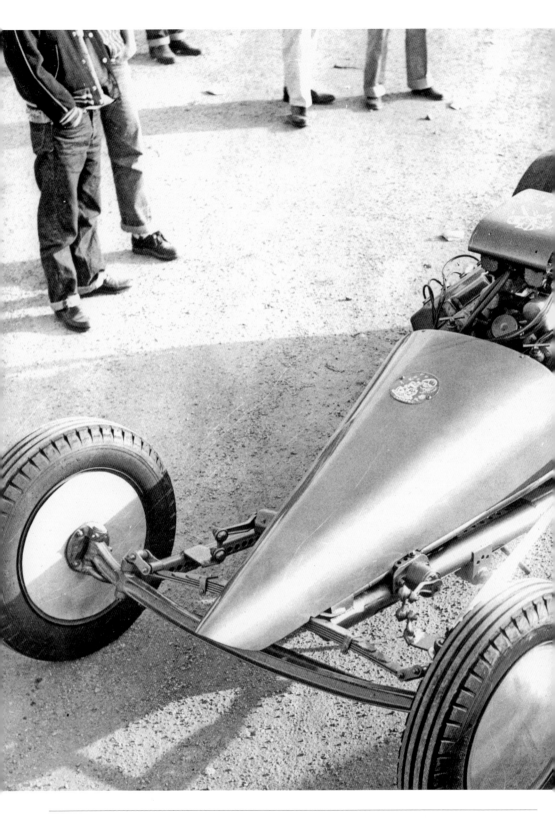

BEAN BANDITS IN PARADISE

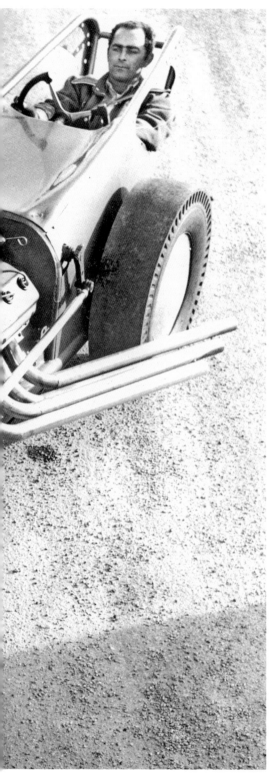

Emery Cook sits in the Cook-Bedwell Isky U-Fab Special. In February 1957 at Lions Drag Strip, Long Beach, California, Cook made two consecutive runs of 165.13 and 166.97 mph. In May 1957 at Colton Drag Strip, he would push the record to 168.85 mph. The Cook-Bedwell stunned drag-strip owners, who were already concerned with the speeds in the 150s. The ban would stand for seven years before dwindling attendance forced the owners to lift it. (Courtesy of the Cook family.)

SAN DIEGO DRAG RACING AND THE BEAN BANDITS

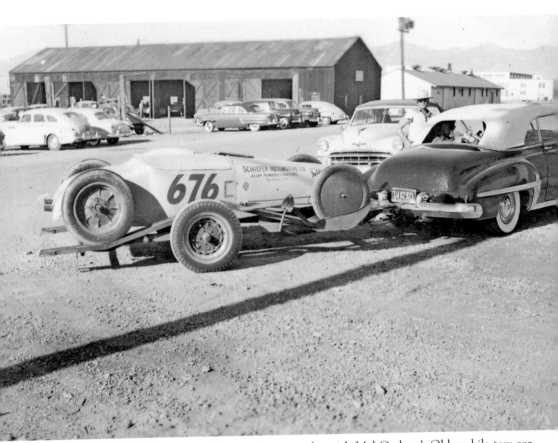

The Schiefer/Arnett rear-engine dragster sits on trailer with Mel Carlson's Oldsmobile tow car. Schiefer had two talented machinist and engine builders working for him: Bruce Crower and Bob Bubenick. Crower soon began his own performance company, and Bubenick became a top racing mechanic on Indy 500 cars. Crower would later join Schiefer in the International Drag Racing Hall of Fame. (Courtesy of Fred Angelo.)

TWIN ENGINE DRAGSTER—166 ON GAS!

CAR CRAFT

APRIL 1959
25c

16 PAGE PICTORIAL

The "Best" In Street Coupes and Sedans

NATIONAL ¼ MIDGET CHAMPIONSHIPS
Phoenix Results and Coverage

This cover of *Car Craft* features Andy Bekech and his car chopped by Joaquin Arnett. By the time Bekech had asked Arnett to chop his car, Arnett was already known as a top body man. Arnett, with the help of his father, built a small garage next to his parents' house and began to mess around with his own projects. (Courtesy of the Prowlers.)

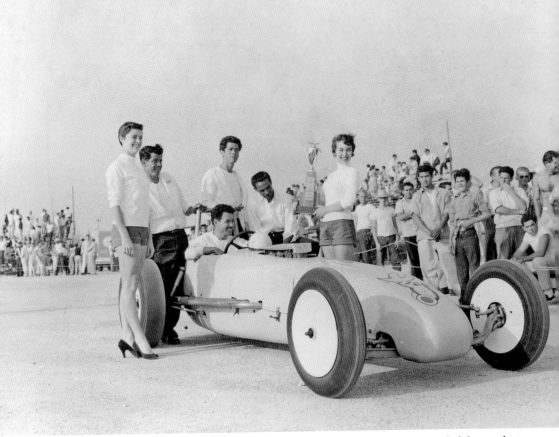

The Bean Bandits in the winner's circle was a familiar sight at drag strips in California during the early years of drag racing. As Arnett stated of those times, they "got busy." They were either taking on all-comers at Paradise, or they were on the road. The sight of the yellow Bean Bandits dragster pulling into the pits meant a long weekend for many competitors. "We didn't win them all but we knew we were heavy duty," Arnett once said. In this 1953 photograph, Carlos Ramirez is in the driver's seat, and the men around the car are, from left to right, Eddie Espinoza, Ernie Espinoza, and Leo Layva. (Courtesy of Ruben Lovato.)

3

JOAQUIN ARNETT

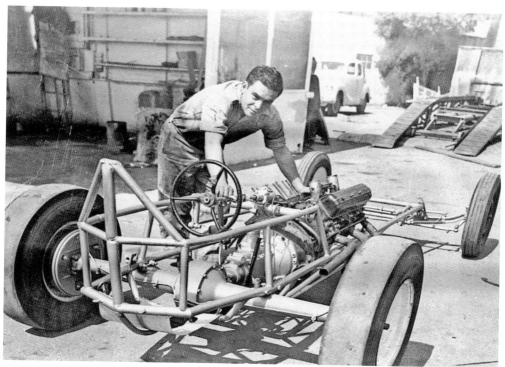

Joaquin Arnett is pictured with his "slingshot" twin-engine dragster. Arnett and the Bean Bandits visited John Vesco at his East San Diego shop and proceeded to draw Arnett's idea for a new dragster on the shop floor with chalk/soapstone. Vesco had built the first narrow streamliner in 1950 and was the perfect guy for the Bandits to talk to about placing the driver behind the rear axle. Since it had not been done before, the discussion centered around good bracing, joints, and driver safety. (Courtesy of Ruben Lovato.)

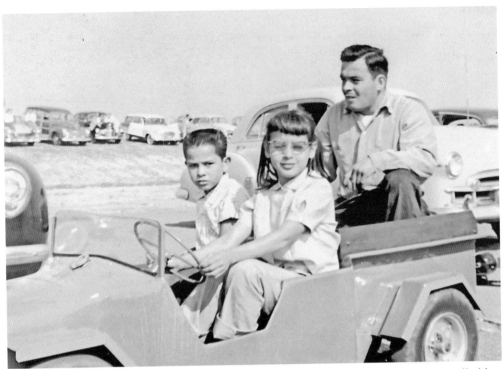

Joaquin Arnett built this miniature motorized car for his daughter Jackie, which she called her "putt-putt." With a laugh, Jackie states that she guesses she always knew how to drive. At home, she would siphon gas from the roadster in their backyard, gas up the putt-putt, and then cruise the alleys of the barrio with the neighborhood kids. In the passenger seat is Leo Leyva's son David Leyva. Arnett seems quite impressed with his daughter's driving. This image was captured at the Paradise Mesa Drag Strip in 1954. (Courtesy of Ruben Lovato.)

Sonny and Jackie Arnett are pictured around 1951 at Twenty-Ninth Street and Logan Avenue in Logan Heights in front of dad's dragster. With fast cars in her DNA, it would not be too long before a nine-year-old Jackie would learn to pop the clutch on her miniature motorized car and take the neighborhood kids for a spin. Unfortunately, not having a valid driver's license landed her in traffic court, with her dad at her side. (Courtesy of Ruben Lovato.)

JOAQUIN ARNETT

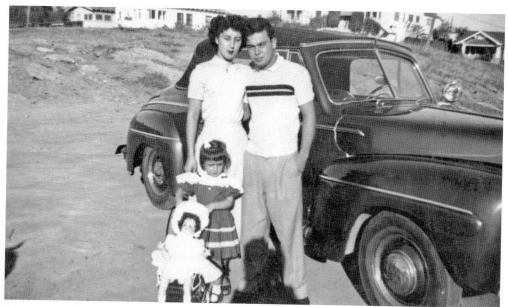

Joaquin, Viola, and Jackie Arnett pose on J Street in front of a ragtop. After the war, Joaquin kept busy working several odd jobs but his break came when L.E. Burners, having heard he had chopped a Model A, offered him job at his shop making sheet-metal panels for armored trucks. (Courtesy of Ruben Lovato.)

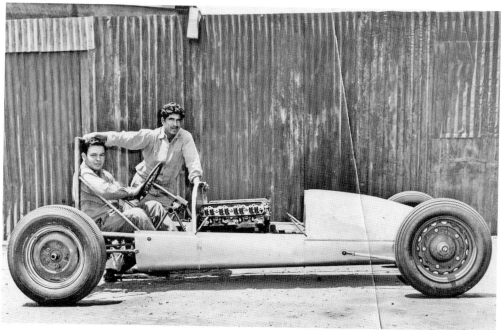

Joaquin Arnett is seated in the Mark II dragster, with Andrew Ortega. The photograph was taken behind Burners' Auto Body Shop. After working on armored trucks, Burners put Arnett to work making Packard and Buick grills for his client Harry Sherwood, who owned the Packard dealership. (Courtesy of Ruben Lovato.)

SAN DIEGO DRAG RACING AND THE BEAN BANDITS

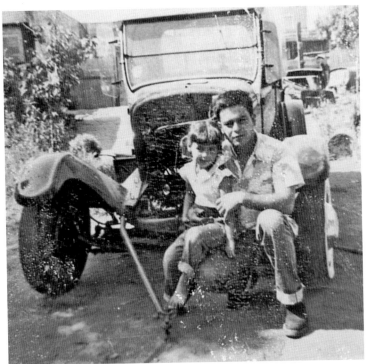

Joaquin and Jackie Arnett are pictured here. Jackie writes, "I loved being with him. He took me to events and drove me all around, even when I was a teen. I liked the excitement of Paradise. Back then, there were no pit passes; I ran all over that strip—dad made us the little 'putt putt,' and I loved driving that little car! Of course, as a kid, who wouldn't love that! Such fun." (Courtesy of Ruben Lovato.)

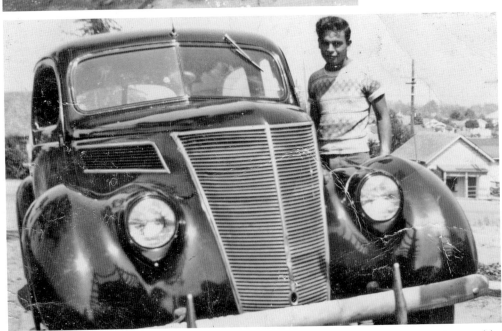

Joaquin is seen in front of his house at 2861 J Street with another car. After the war, Arnett, like many veterans, picked up with his cars and hot rodding. Arnett states that back then, Miramar Road was just a two-lane road, and there was nothing between Mission Valley and Poway, except a couple of gas stations. Arnett and future Bean Bandits would park alongside the road and wait for someone to show and challenge them. (Courtesy of Ruben Lovato.)

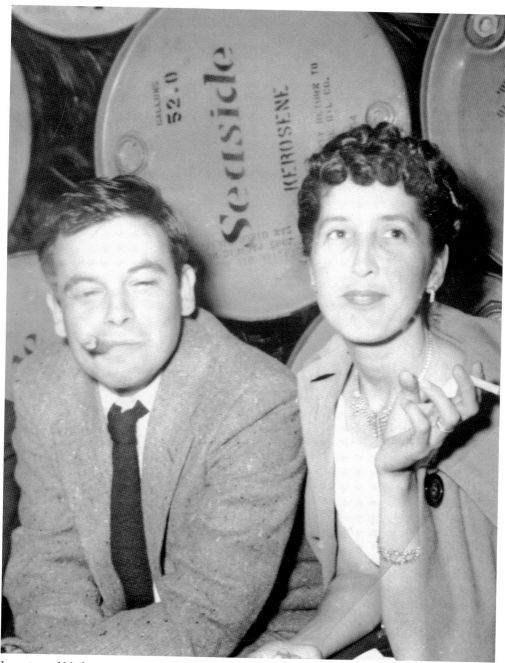

Joaquin and Viola are pictured at a holiday party at Mike Nagem's Seaside Service Station. Joaquin said when they were just kids, he wanted to impress Viola during a neighborhood baseball game, but when his foul ball broke a window, he turned to Viola, who was the catcher, handed her the bat, and took off running. (Courtesy of Jackie Arnett.)

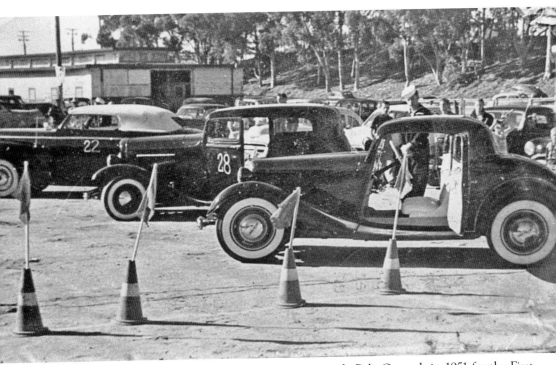

In the foreground is the 1934 coupe shown at the Coronado Polo Grounds in 1951 for the First Annual Reliability Run presented by the Knuckle Busters Car Club of Coronado. In 2000, Arnett's coupe was given the Preservation Award at the Detroit Autorama show. The Preservation Award is given to honor vehicles or individuals that exemplify the heritage and character of the hot rod hobby. This coupe is known as the Arnett-Granatelli-Couch. (Courtesy of Ruben Lovato.)

JOAQUIN ARNETT

Joaquin works on the Mark II dragster. The dragster is getting a sprinter nose. Arnett's garage was built with the help of his father. Arnett could build not just engines and cars but also homes. He built his home on a hill in El Canto and lacking access to the main road borrowed a bulldozer and graded his own one-lane access road. The city officials were not happy, but the road remained and is still in use today. (Courtesy of Ruben Lovato.)

Joaquin Arnett (seated), Andrew Ortega, and the Mark II dragster are seen in the alley behind Burners' Auto Body Shop. Arnett's freelance work was growing at this time, and he would soon leave to build his own shop. Ortega worked at one of the many tuna canneries as an "oven man," loading racks filled with tuna into the ovens. Arnett stated that it was "hell to work there" (at the cannery). Ortega, Arnett said, was like his right arm and became a "hell of a bodyman." (Courtesy of Jackie Arnett.)

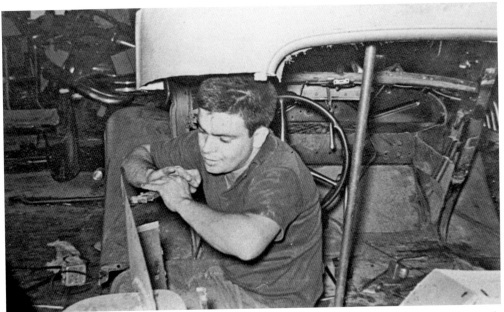

Here, in 1949, Joaquin chops the 1934 coupe, which would become one of the iconic hot rods of all time. Two years later, Arnett would win a craftsman award for this car at the Los Angeles Motorama, held at the Pan American Building. The car would be bought on the exhibit floor by Andy Granatelli, a speed-shop owner in Michigan who would later go on to become an Indy driver and leader in engine lubricants, founding the company STP. (Courtesy of Ruben Lovato.)

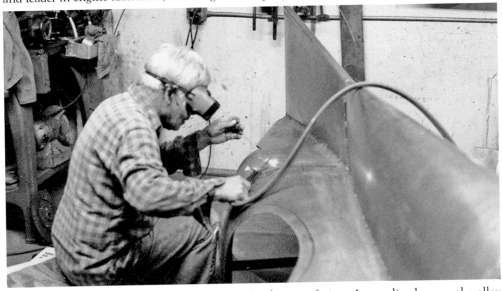

Joaquin Arnett welds the Mark I streamliner. At the age of nine, Arnett lived across the alley from Edgar's Auto Body and Welding Shop. His first job was cleaning the shop at the end of the day. Later, he was responsible for setting up the grinding disc. He would dip rags into a pot of glue, followed by barrels of sand, with each barrel containing a different grit of sand; they were then hung to dry. In the morning, the rags were glued to discs. (Courtesy of Ruben Lovato.)

JOAQUIN ARNETT

Joaquin Arnett working on the Mark I streamliner. In 1937, at the age of 14, Arnett went to work at Howard's Welding Shop on the waterfront near the county administration building on Kettner Boulevard. Howard's welded hook racks for the tuna boats and built fire escapes for the city. Howard was also the blacksmith for the Del Mar racetrack. (Courtesy of Ruben Lovato.)

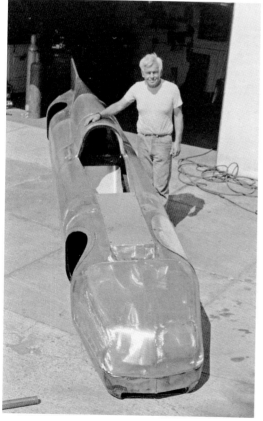

Joaquin Arnett poses with his streamliner metalwork. Arnett received his welding certification at the age of 14, when, at Howard's Welding Shop, Coast Guard officials walked in and threatened to close the shop because Howard did not employ any certified welders. No one stepped forward, and young Arnett was "volunteered." (Courtesy of Ruben Lovato.)

SAN DIEGO DRAG RACING AND THE BEAN BANDITS

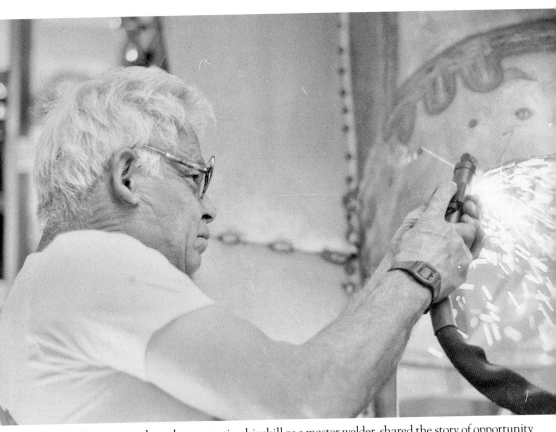

Joaquin Arnett, seen here demonstrating his skill as a master welder, shared the story of opportunity knocking at Howard's Welding Shop: "They were really good welders, and some of them had been welding 20 years, and they didn't want to go to school to learn what they already knew. So, Howard turned to me and said, 'Joaquin you're going to school.' I jumped up and said, 'Alright!'" (Courtesy of Ruben Lovato.).

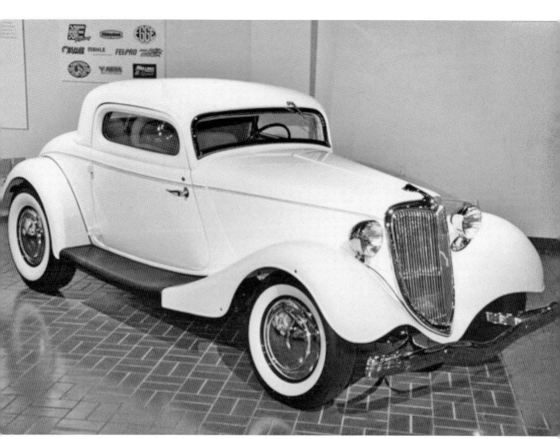

Pictured here is the famous 1934 Ford coupe bought by Andy Granatelli and now owned by Bill Couch. Arnett built the car for the 1951 Los Angeles Motorama. He chopped 4 inches from its height and sectioned 11 inches from its length. (Courtesy of the Motor City Garage.)

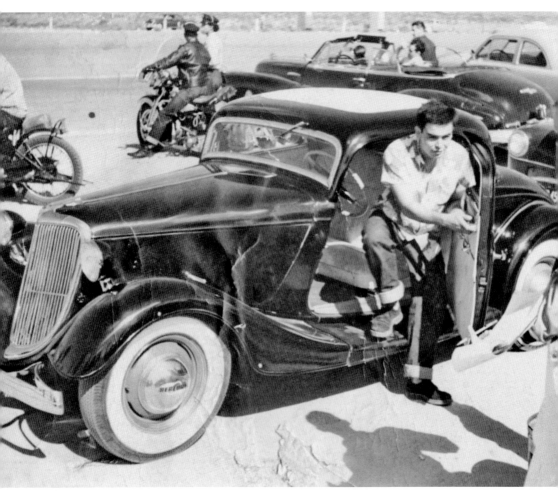

Joaquin Arnett is stepping out of the three-window coupe at the Paradise Mesa Drag Strip staging area. The coupe, like most cars Arnett built, would find its way to the drag strip. Arnett was always finding cars to work on and apply his skills as a body and fender man. (Courtesy of Ruben Lovato.)

This image was captured while the coupe was being sanded. Joaquin Arnett attended Red Sanders' Welding School, located at the foot of Market Street in San Diego. Arnett has recalled that Sanders told the class that welding was like playing music—only 1 in 100 will have the talent for it. Arnett was told that he had the talent in spades. "I don't know why, but it just came natural to me," Joaquin stated. (Courtesy of Ruben Lovato.)

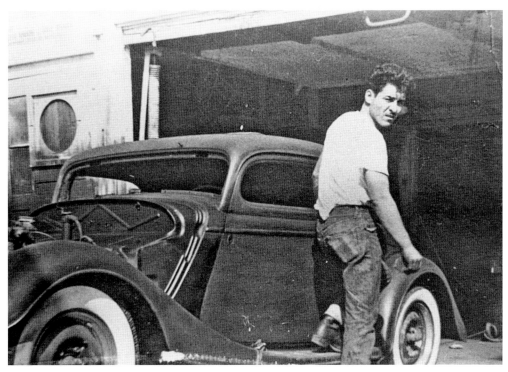

Carlos Ramirez is pictured with the coupe. Joaquin Arnett would leave Howard's Welding Shop and return to Edgar's Auto Body and Welding Shop, where he first swept the floors and prepared the next day's sanding rags. Now, he would build the inner walls of armor trucks. It was here that Arnett learned to "control metal" from master welders Billy Keene and Bruce Barnes. (Courtesy of Ruben Lovato.)

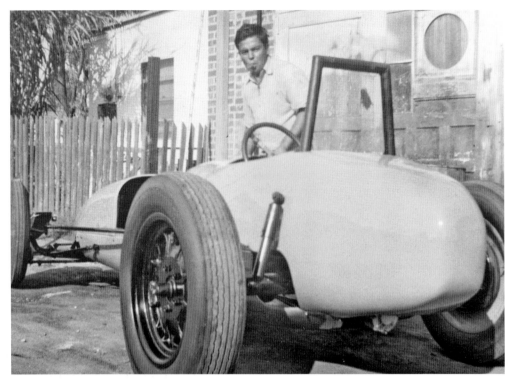

Joaquin Arnett puffs on a cigar with a dragster behind Burners' Auto Body Shop at Thirty-Fifth Street and University Avenue. This is the second full-body dragster built by Arnett. The Mark II, according to Pat Durant, was much faster off the line. The Mark I would always have to catch them at the end. (Courtesy of Ruben Lovato.)

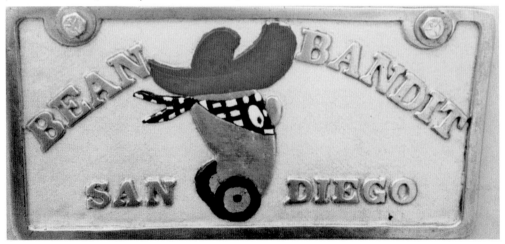

This Bean Bandit plaque was designed by Native American Billy Galvin. Arnett stated that Galvin first painted the Bean Bandits logo on their maroon-colored car taken to Miramar Road for some pre-paradise drag racing. Galvin had come up with the idea and design in response to a sign posted at a service station in Adelanto, California, on the way to El Mirage Dry lakes in 1948: "No Mexicans or dogs allowed." (Courtesy of the Bean Bandits Collection.)

NOSTALGIA RACES, HONORS, AND INDUCTIONS

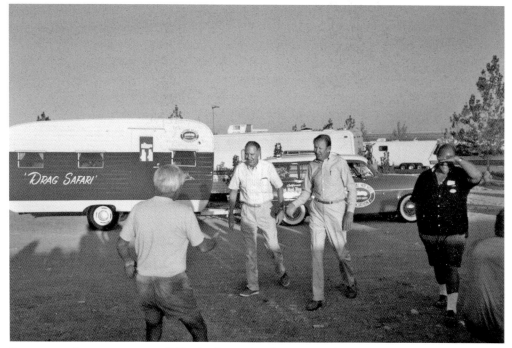

Four years after reuniting in 1988, the Bean Bandits were making appearances (some paid) at nostalgia races, car shows, and exhibits. Here, Joaquin welcomes Wally Parks and Alex Xydias (So-Cal Speed Shop founder) to the Bean Bandits burrito party in August 1992 during a weekend nostalgia event. Parks and Xydias brought the famous Drag Safari trailer along. Arnett and the Bean Bandits were part of the first two safaris. The safaris would travel the country teaching timing associations how to set up and run drag races safely, and they were instrumental in making drag racing a national sport. From left to right are Arnett, Parks, Xydias, and John Zenda of the NHRA. (Courtesy of the Bean Bandits Collection.)

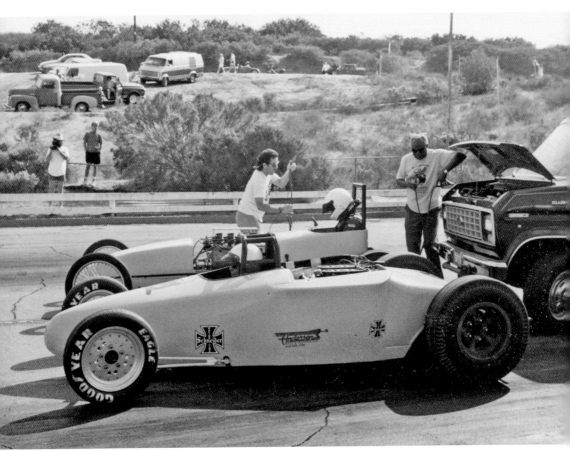

Joaquin (in the rear-engine dragster in foreground) and Sonny Arnett (in the Mark I dragster in the background) are pictured at Carlsbad Raceway Antique Race. The rear engine roadster was the impetus for the Bean Bandits reuniting. This is not the famous Schiefer roadster modified by Arnett; that car was destroyed in a wreck when it was the Henslee-Cook car in 1957. This is Arnett's rear-engine roadster, which was stolen in 1961. Arnett found it a decade later in someone's backyard. Once recovered and restored, Sonny wanted to take it racing. Joaquin then built a replica of the Bean Bandit dragster and started up once again. (Courtesy of the Bean Bandits Collection.)

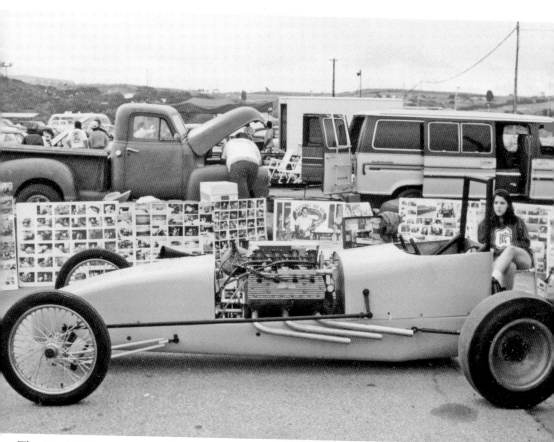

The Mark II dragster is on display with photographs in the background depicting the early years of the Bean Bandits and drag racing. Many of those images appear in this book, thanks to Ruben Lovato preserving the negatives. The Bean Bandits booth and exhibits were a main attraction to drag racing and hot rodding fans at these nostalgia races. (Courtesy of the Bean Bandits Collection.)

Another tradition kept by the Bean Bandits after reuniting was their carne asada, the Mexican version of a barbecue. From the very beginning, the Bean Bandits were known for their hospitality and the sharing of food and drinks. (Courtesy of the Bean Bandits Collection.)

NOSTALGIA RACES, HONORS, AND INDUCTIONS

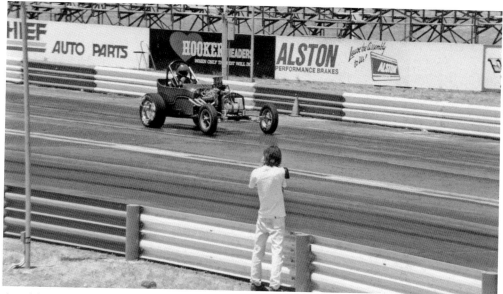

An old-time dragster drives down the strip. In the early 1970s, a group of hot rodders wanted to preserve and pay homage to the Ford Flathead engine and so formed an association and began racing them in an effort to show their importance to the history of drag racing, hot rodders, and car culture in general. From that, other antique and nostalgia organizations formed, and by the late 1980s these races were being held across the country. (Courtesy of the Bean Bandits Collection.)

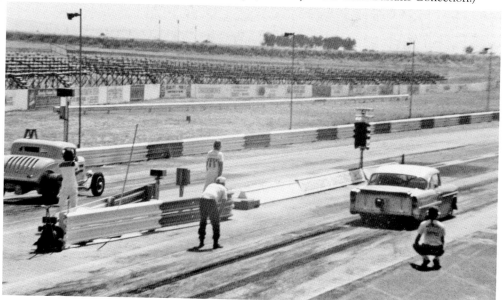

Two more old-timers take off. Nostalgia racing, which began as a fun way to get out the old roadster and dragster for one more trip down memory lane, has turned into a thriving sport of its own. Wally Parks NHRA Motorsports Museum opened 1998, dedicated to "celebrating the impact of motorsports on our culture," and in 2008 the museum created the NHRA Hot Rod Heritage Series. (Courtesy of the Bean Bandits Collection.)

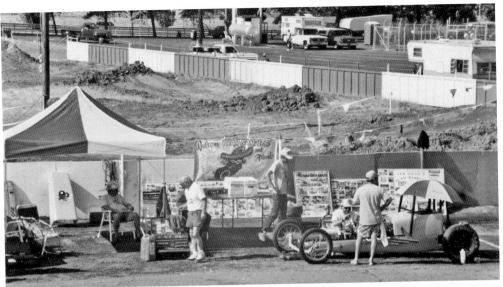

This is the Bean Bandits' usual setup at an event, complete with canopy, photographs, and dragster. Here, at the nostalgia race in Sacramento, the dragster is having some engine problems, and Sonny Arnett is having a go at it. It looks like Joaquin Arnett is doing some heavy thinking as he walks away, or perhaps he is just going to let Sonny handle it. (Courtesy of the Bean Bandits Collection.)

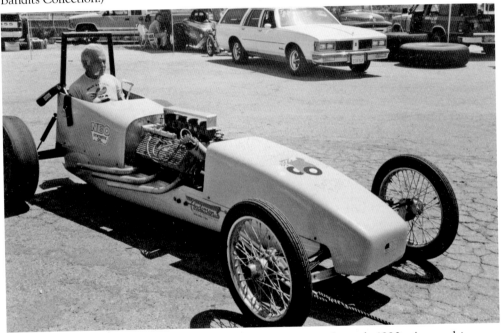

Joaquin Arnett is pictured in a dragster at a nostalgia event in the early 1990s. Among his many accomplishments, Arnett was known as a pioneer in running large amounts of nitro. He not only had a formulation that worked, but he also subsequently learned to modify his carburetors to maximize the loads. (Courtesy of the Bean Bandits Collection.)

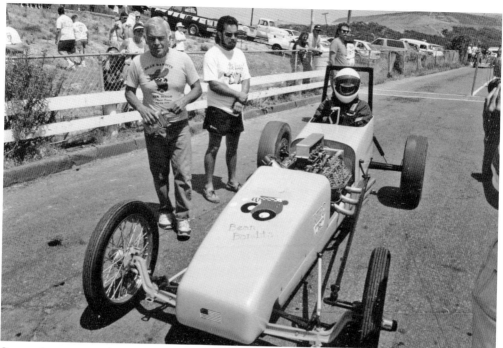

Sonny Arnett is ready to go in the rebuilt Mark II dragster at the Carlsbad Raceway Nostalgia Race. Carlsbad Raceway was located in Northern San Diego County and opened in 1965 with the help of Jim Nelson, co-owner of Dragmaster Inc., who took a year's leave from his company to start the raceway. (Courtesy of the Bean Bandits Collection.)

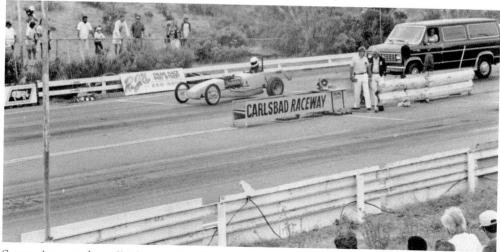

Sonny Arnett takes off. The Carlsbad Raceway was considered the last of the old drag strips, at a time when all a track operator needed was enough room for a .25-mile strip, a little area for a grandstand, and a timing tower. The raceway was the first to use guardrails. "It wasn't a fancy place, but the guard rails were painted, the parking areas marked out and the hillsides mostly covered with native grassland, which didn't look too bad when you looked at it from a distance," Jim Nelson said in the *San Diego Union-Tribune*. (Courtesy of the Bean Bandits Collection.)

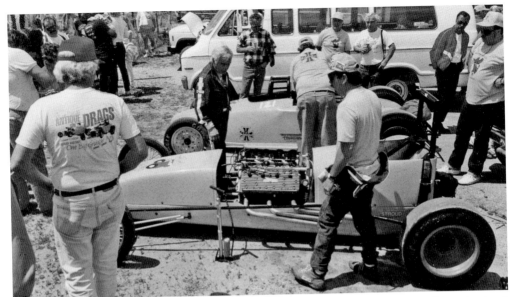

Sonny and Joaquin Arnett and the dragster are in the pits at the Carlsbad Antique Drags in April 1991. In the foreground is the Bean Bandits dragster that won the first sanctioned NHRA event in 1953 at the Pomona Drag Strip. Behind the dragster is the rear-engine roadster. (Courtesy of the Bean Bandits Collection.)

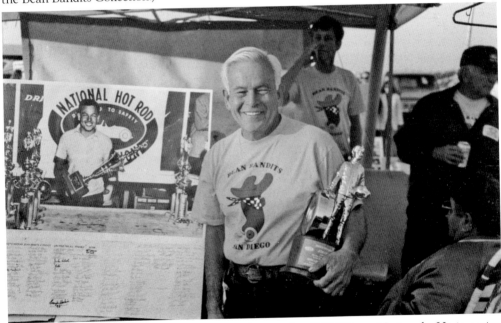

Joaquin Arnett holds the Wally presented to him at the 1993 Winter Nationals. He is posing with the original photograph from the first NHRA-sanctioned event in 1953, won by Arnett and the Bean Bandits. The Wally is drag racing's most prestigious trophy and was presented to Arnett in honor of that victory during October 1993 in Pomona, California. (Courtesy of the Bean Bandits Collection.)

NOSTALGIA RACES, HONORS, AND INDUCTIONS

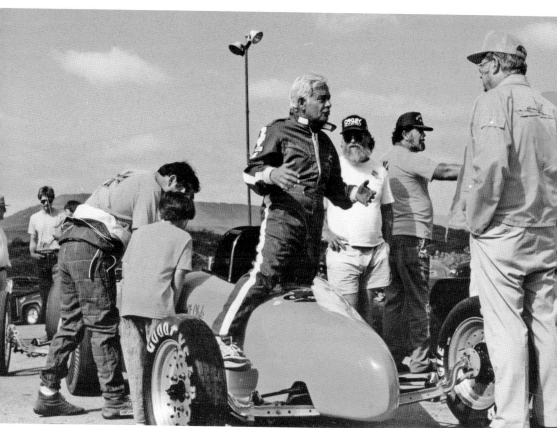

Joaquin Arnett is suited up, with Sonny Arnett behind him prepping the cockpit. The nostalgia races gave Sonny, Joaquin, and the youngest son, Jeff, the outlet for their competitive nature. Before the return to drag races, during Joaquin's "retirement," he and his sons would venture into Baja California and race motorcycles for fun along the dusty dirt roads. (Courtesy of the Bean Bandits Collection.)

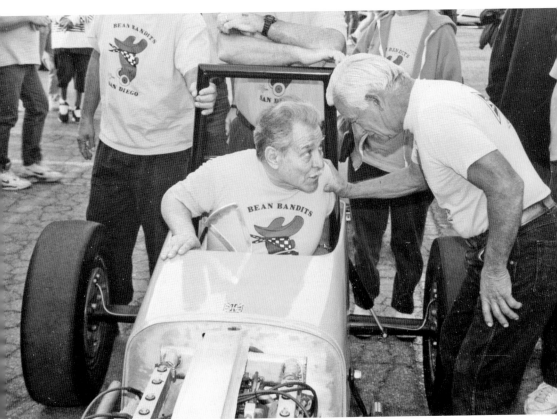

An iconic scene of 1950s drag racing was Carlos Ramirez getting last-minute instructions from Joaquin Arnett. Arnett would tell Ramirez to "let her rip." Here they are, getting ready to be honored at the 1993 Winter Nationals 40 years after Carlos drove the Mark II dragster to victory at the first championships held by the NHRA in 1953. This image was captured in Pomona, California, on October 30, 1993. (Courtesy of the Bean Bandits Collection.)

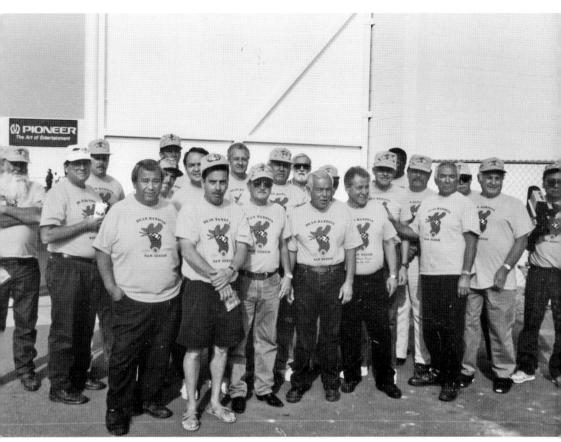

The Bean Bandits received a hero's welcome prior to the NHRA Winter Nationals. At far left is Robert Martinez with a beard. Pictured here from left to right are (first row) Pat Durant, Sonny Arnett, Gene Arrey, Joaquin Arnett, and Carlos Ramirez; (second row) Paul Green, an unidentified Ramirez son, Bill Tincup, Mike Uribe, Bob Maddocks, Bill Freeman, Richard Agundez, Marco Miranda, Mike Nagem, and Ruben Lovato; (third row) Jerry Freitas, Ron Wagner, James "Cowboy" Patterson, J.J. Jensen, Jack John McLenachen, and Harold Miller. (Courtesy of the Bean Bandits Collection.)

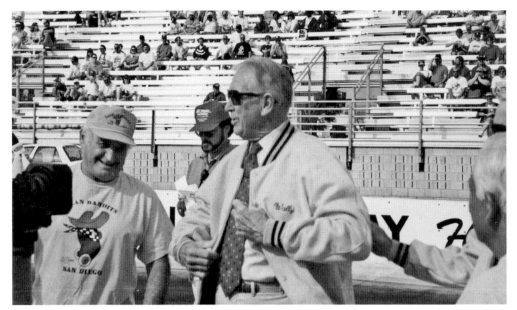

Mike Nagem presents Wally Parks with his Bean Bandits jacket. Longtime friend of the Bean Bandits and founder of the NHRA, Parks wanted to know why his wife had received a Bean Bandits jacket decades ago and was made a member but he had not. Joaquin told him he would have to become a member and wondered how come the Bean Bandits had not been recognized for what they did all those years ago. Wally got his jacket, and the Bean Bandits got their parade and recognition. (Courtesy of the Bean Bandits Collection.)

The gang's all here at a 1992 nostalgia race. Leaning against the Drag Safari station wagon are, from left to right, Alex Xydias, ? Stroker, John McCabe, Wally Parks, Joaquin Arnett, Chick Cannon, and Mike Nagem. Kneeling in the first row are Sonny (left) and Jeff Arnett. Wally and his wife, Barbara, would sometimes attend the Bean Bandits dances held at the Manor Hotel on Fifth Street in Bankers Hill, San Diego, California. (Courtesy of the Bean Bandits Collection.)

5

BONNEVILLE
AND THE LAKES

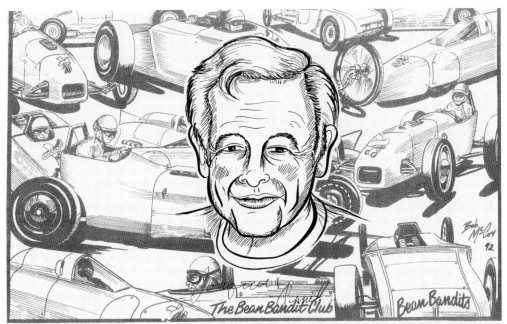

By 1988, nostalgia and antique drag racing had become popular, and the Bean Bandits decided to start up the club again and go racing. They held a reunion party as a fundraiser, and by 1993 the reunion parties were drawing over 400 attendees. Artist Bob McCoy pitched in by designing the 1992 poster. In 2008, the NHRA created the "living history" NHRA Hot Rod Heritage Series to support the Wally Parks Motorsports Museum. (Courtesy of the Bean Bandits Collection.)

Joaquin Arnett is in the cockpit of the Mark II streamliner in his NHRA dragster hat. Arnett was always interested in going fast. As a kid, he stated he would roller skate from his father's nursery in Old Town San Diego, to their home in downtown San Diego (four miles) and that, later, all the miles of training came in handy because during the Depression, he would enter roller-skating races and come home with the prize: a bag of groceries. (Courtesy of the Bean Bandits Collection.)

Joaquin Arnett is ready for a run at the Dry lakes in 1993. In the late 1940s, Arnett was known to have a way with nitromethane, a fuel costly to engines when not properly mixed. His knowledge came from a serendipitous meeting with a rocket scientist who was laid up next to Arnett in the San Pedro Naval Hospital during the war. The scientist was formulating rocket fuel to launch projectiles from naval warships. (Courtesy of the Bean Bandits Collection.)

Sonny Arnett is all smiles in front of a streamliner after having just broke his old class record 192.010 mph with the 240-cubic-inch Ardun Ford motor from 1949. The new record of 202.743 also got him into the prestige's 200 MPH Club. This is the same Ardun engine Joaquin bought from Zora Arkus-Dontov all those years ago. This image was captured in El Mirage on July 14, 1991. (Courtesy of the Bean Bandits Collection.)

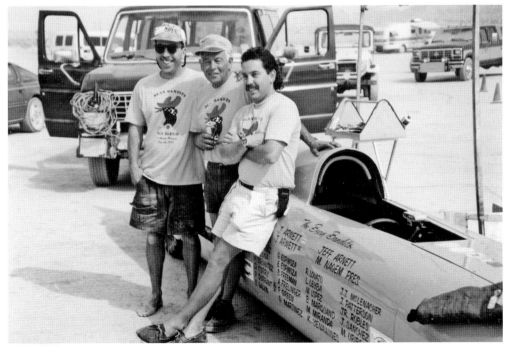

Pictured from left to right are Sonny, Joaquin, and Jeff Arnett at the dry lakes in 1993. Behind them is the Mark II. Joaquin built the streamliner to make a run at the world land speed record. Arnett ran two engines in this streamliner: a 392-cubic-inch Chrysler Hemi and a 480-cubic-inch Chrysler Hemi. It was designed for a top speed of 450 mph. (Courtesy of the Bean Bandits Collection.)

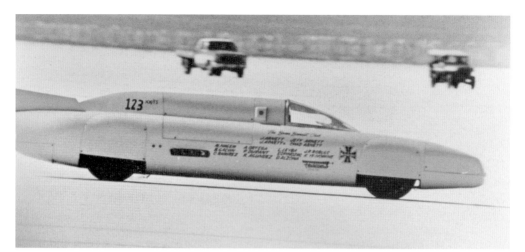

The Mark I streamliner is pictured here during its record run at El Mirage on June 9, 1991, running the 240-cubic-inch 1949 Ardun Ford motor. This was the first step in Sonny Arnett's dream to capture the world land speed record. It was a goal Joaquin and the Bean Bandits began to chase in earnest in 1954 when Arnett acquired a P-51 Mustang motor. (Courtesy of the Bean Bandits Collection.)

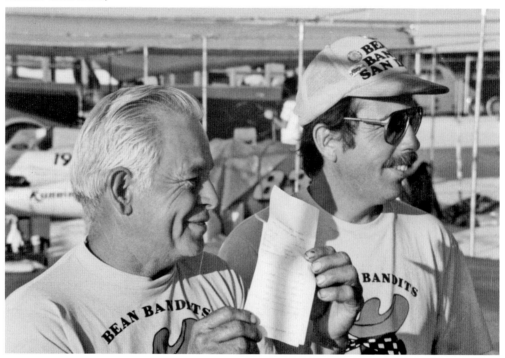

Joaquin Arnett is proudly holding the slip showing the class-record run set by Sonny Arnett with 317 mph in the Mark I streamliner with the fuel-injected 240-cubic-inch 1949 Ardun Ford motor at the Bonneville Speed Week on August 18, 1991. At this same meet, Al Teague set a new world record of 409.978 mph for a "piston-driven" engine, a record that had been held for 26 years by Bob Summers in his "Goldenrod." (Courtesy of the Bean Bandits Collection.)

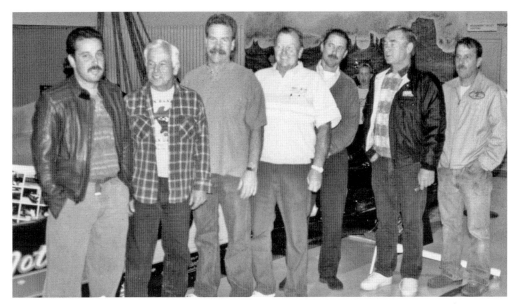

These speed demons are photographed at the San Diego Automotive Museum on March 28, 1993. From left to right are Jeff Arnett, Joaquin Arnett, Rick White, Nolan White, Al Teague, Bruce Crower, and Sonny Arnett. (Courtesy of the Bean Bandits Collection.)

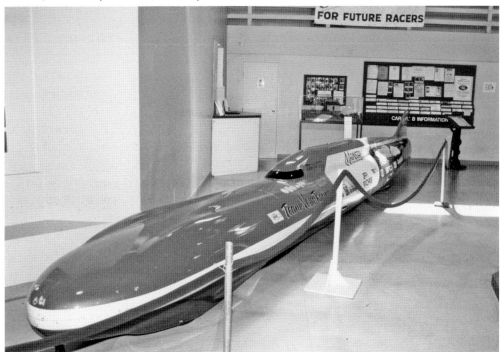

Seen here is Don Vesco's 318-mph Kawasaki-powered streamliner. In 1999, Vesco would drive his "Turbinator" to a SCTA/BNI (Bonneville National Inc.) record of over 427 mph. However, he failed to comply with the slightly more restrictive rules of the Federal International De L' Automobile (FIA). (Courtesy of the Bean Bandits Collection.)

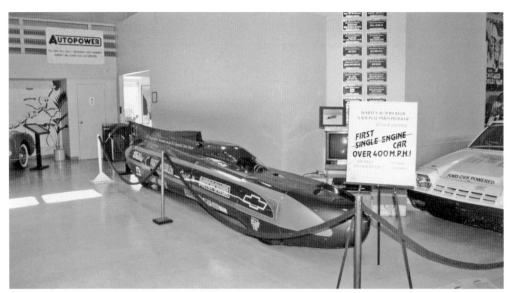

Nolan White's streamliner was touted as the first car over 400 mph. White had the previous world record at 384 mph before Al Teague surpassed it with 409 mph. In order to set an official record, a car must make two passes (up and back) within a designated time. The passes are then combined to determine an average time. Therefore, White could tout his as being the first car to surpass the 400-mph mark, but his official speed was 384 mph. (Courtesy of the Bean Bandits Collection.)

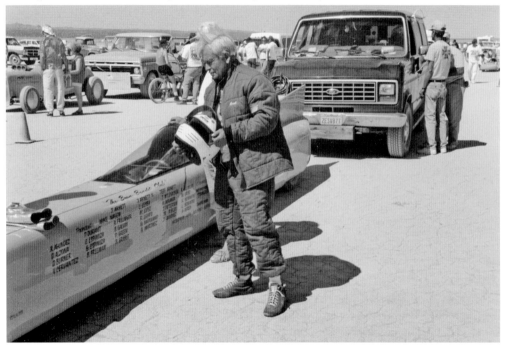

Joaquin Arnett suited up for a run at El Mirage Dry lakes in 1993. Arnett had first run at El Mirage in the late 1940s, and here he is, 50 years later and still going. Arnett built the Mark II streamliner in 30 days in his garage with the help of his sons. (Courtesy of the Bean Bandits Collection.)

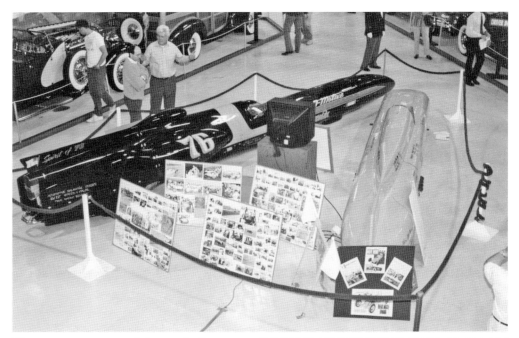

The image was captured during the Bean Bandits Car Show at the San Diego Automotive Museum on March 28, 1993. The Bean Bandits Mark II streamliner is paired with Al Teague's "Spirit of '76" streamliner. At the time, Teague held the world land speed record of 409.986 mph. The Mark II held a class record at 317 mph. (Courtesy of the Bean Bandits Collection.)

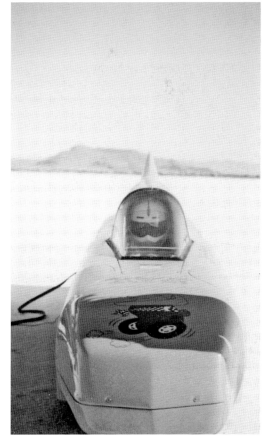

Sonny Arnett is pictured in the Mark I streamliner. The streamliners that Arnett ran were a mix of old and new technology in that the engine could be one of the 239-cubic-inch Ford Flatheads built in the 1940s but were wired with state-of-the-art software by SEMCO, a systems engineering firm owned by Bill Tincup. Tincup was developing and experimenting with a cockpit communications system and a computer monitoring data system. These onboard data acquisition systems would become widely used a decade later. (Courtesy of the Bean Bandits Collection.)

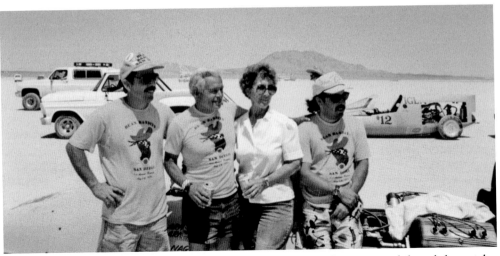

It was always a family affair for Joaquin Arnett. Here is a family portrait of, from left to right, Sonny, Joaquin, Viola, and Jeff as they enjoy Sonny's record run and entrance into the 200 MPH Club at El Mirage in 1991. (Courtesy of the Bean Bandits Collection.)

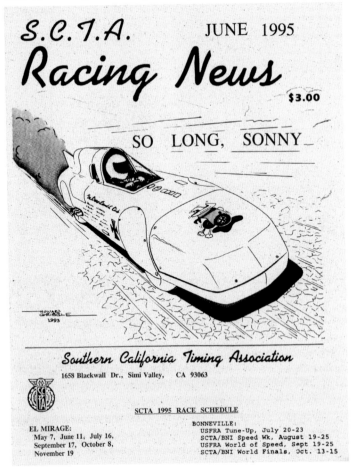

This cover is a tribute to Sonny Arnett, who crashed and lost his life at El Mirage Dry lakes in May 1995. At the time, he held three world land speed class records. The Bean Bandits suspended operations through 1996. In 1997, Joaquin and Jeff Arnett built the Mark III streamliner and, with Jeff as driver, returned to El Mirage to continue pursuing Sonny's dream of setting the world land speed record. (Courtesy of the Bean Bandits Collection.)

After the passing of the Sonny Arnett, Joaquin Arnett needed time to process the tragic event, but in time, he came to understand, as he stated to Carlos Ramirez, that "these things happen." The Bean Bandits regrouped with the youngest Arnett son, Jeff, taking over the driving duties with the goal of going after the world land speed record held by Al Teague of 409 mph. This photograph was taken in Bonneville, Utah, in 1998. (Courtesy of Emmanuel Burgin.)

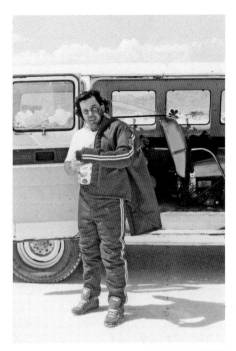

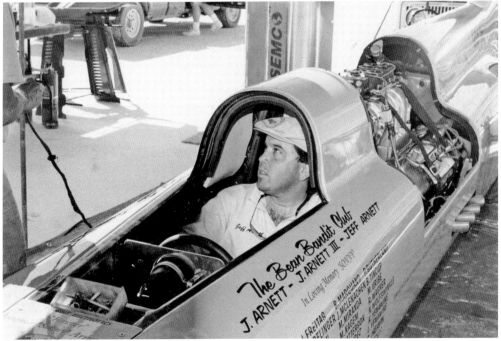

Jeff Arnett sits in the Mark IV streamliner, preparing the car for 300-mph-plus run. The engine is a Chrysler Hemi first used in the Mark I dragster in 1953. Drag-racing pioneer Holly Hedrich, recognizing the engine from the old days, asked rhetorically if that was the Hemi from 1953 and stated, "Heck, Joaquin, that engine is as old as me, and I'm as old as dirt." (Courtesy of Emmanuel Burgin.)

Taking a moment to watch a run are, from left to right, Pat Durant, Buff Marquand, Joaquin Arnett, and Jeff Arnett's future wife, Karen. (Courtesy of the Bean Bandits Collection.)

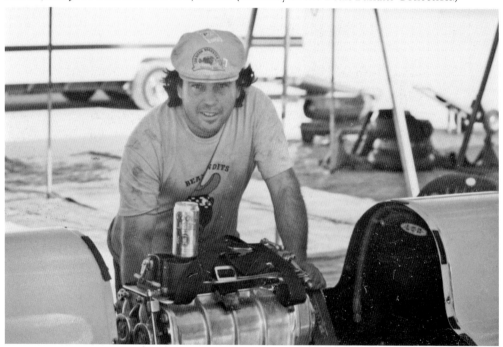

Jeff Arnett hydrates while working on the engine. Arnett would earn his Bonneville licenses and become eligible to pursue the land speed record of Al Teague. Jeff and Sonny Arnett received tools as presents and were taught by their dad, with both becoming highly skilled "wrench men." Jeff would become a Southern California Timing Association (SCTA) official. (Courtesy of Emmanuel Burgin.)

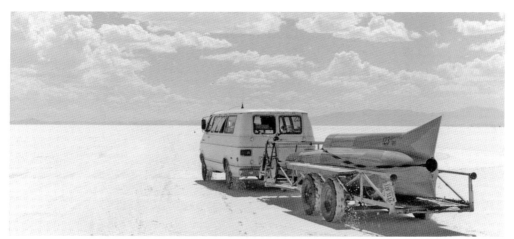

The end of another Speed Week has come to an end, with the Bean Bandits' assault on the world record falling short. The hand-built Mark II has been put on its trailer, a modified boat trailer, and the van is heading to San Diego. Although Joaquin and Jeff Arnett and the original Bean Bandits never fulfilled Sonny's dream, a new generation of Bean Bandits are assuming the mantle. This image was captured at the Bonneville Salt Flats in Utah in 1998. (Courtesy of the Bean Bandits Collection.)

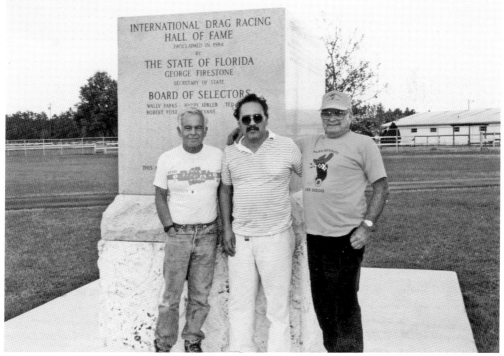

From left to right, Joaquin Arnett, Ruben Lovato, and Mike Nagem pose at the International Drag Racing Hall of Fame monument in 1992 Ocala, Florida. As team photographer, Lovato learned his trade as photographer in the Army during the Korean War. (Courtesy of the Bean Bandits Collection.)

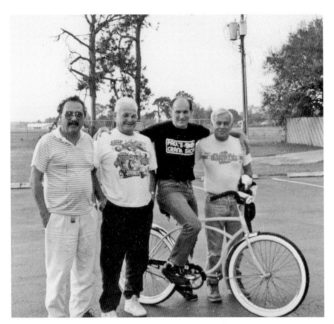

Several of the Bean Bandits made the trip to Ocala, Florida, for Joaquin Arnett's induction ceremony to the International Drag Racing Hall of Fame in 1992. Pictured from left to right are Ruben Lovato, team photographer; Mike Nagem, club president; Don "Big Daddy" Garlits, founder of the Drag Racing Hall of Fame; and Arnett. (Courtesy of the Bean Bandits Collection.)

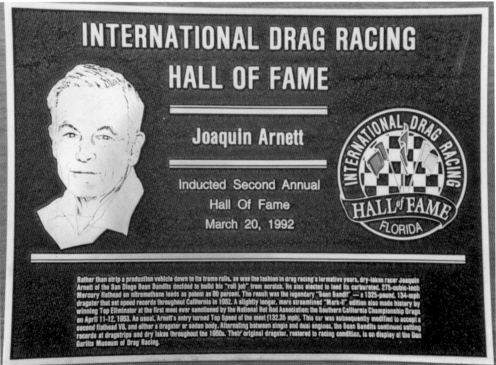

INTERNATIONAL DRAG RACING HALL OF FAME

Joaquin Arnett

Inducted Second Annual
Hall Of Fame
March 20, 1992

Rather than strip a production vehicle down to its frame rails, as was the fashion in drag racing's formative years, dry-lakes racer Joaquin Arnett of the San Diego Bean Bandits decided to build his "rail job" from scratch. He also elected to feed its carbureted, 275-cubic-inch Mercury flathead on nitromethane loads as potent as 80 percent. The result was the legendary "Bean Bandit" — a 1325-pound, 134-mph dragster that set speed records throughout California in 1952. A slightly longer, more streamlined "Mark-II" edition also made history by winning Top Eliminator at the first meet ever sanctioned by the National Hot Rod Association; the Southern California Championship Drags on April 11-12, 1953. As usual, Arnett's entry turned Top Speed of the meet (132.35 mph). This car was subsequently modified to accept a second flathead V8, and either a dragster or sedan body. Alternating between single and dual engines, the Bean Bandits continued setting records at dragstrips and dry lakes throughout the 1950s. Their original dragster, restored to racing condition, is on display at the Don Garlits Museum of Drag Racing.

Joaquin Arnett was inducted into the International Drag Racing Hall of Fame on March 20, 1992. Arnett's abilities are well noted here. The Hall of Fame recognized his initiative to build his "rail jobs" from scratch rather than strip down a car and his knowledge of nitromethane, which culminated into running, record setting and championship winning dragsters. (Courtesy of the Bean Bandits Collection.)

THE NEW BEAN BANDITS

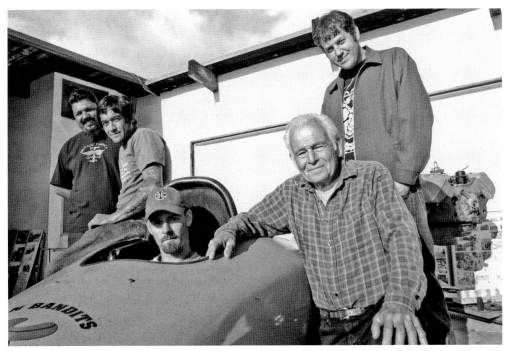

Joaquin Arnett is at his house with new Bean Bandits in 2005; it was on this the day he asked Julio Hernandez to take over leadership of the group. From left to right are Fabian Valdez, Hernandez, Adam Rogers, Arnett, and Dan Waldrop. These were the last four Bean Bandits to be inducted by Arnett; after this, membership was decided by Hernandez and Valdez. (Courtesy of the Bean Bandits Collection.)

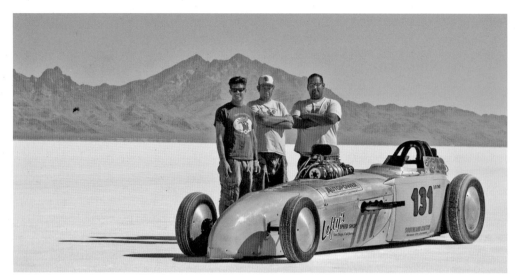

In this picture taken during Bonneville Speed Week in 2015 is Julio Hernandez's roadster, running a 396-cubic-inch Blown Chrysler on fuel. At this event, it ran 212 mph. This is the fastest roadster in the history of the Bean Bandits; in 2016, it ran 242 mph at El Mirage Dry lakes. The crew is made up of, from left to right, Derby Pattengill, Dan Waldrop, and Victor Arrequin. (Courtesy of the Bean Bandits Collection.)

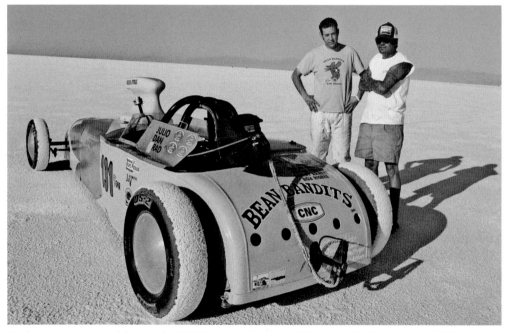

In this image captured during the 2006 Bonneville Speed Week is Julio Hernandez's 1929 roadster, running Wayne Finley's four-cycle 175-cubic-inch engine F/GMR (Fuel Gas Modified Roadster). The new Bean Bandits set their first records with Finley's engine at both Bonneville and El Mirage. Finley was a Bean Bandit in the 1950s. Pictured are Dan Waldrop (left) and Hernandez. (Courtesy of the Bean Bandits Collection.)

THE NEW BEAN BANDITS

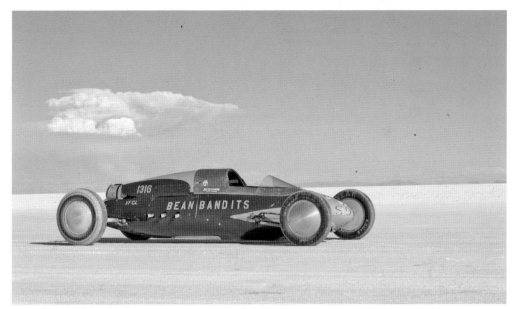

This belly tank is the Bean Bandits P-38 drop tank lakester. It runs a flathead carburetor on gasoline. It ran 156 mph last time at Speed Week and turned a 155 mph at El Mirage. The class record is 196 mph. (Courtesy of the Bean Bandits Collection.)

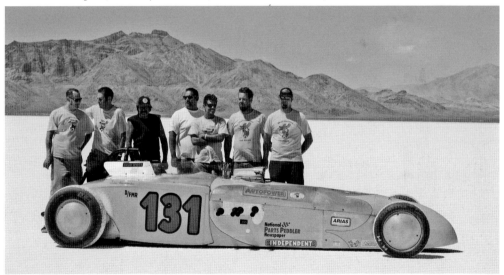

At the 2009 Bonneville Speed Week is Julio Hernandez's roadster, running a 300-cubic-inch Chevy V8 injected on nitromethane; it was built by Rick White. It reached its best speed of 226 mph with Brad White driving. The Bean Bandits ran the No. 131 in honor of Nolan White. White, driving "Spirit of Autopower," averaged 413.156 mph for two runs on the salt on August 12 in the SCTA speed trials in 2002 but died of injuries trying to set the official FIA (Federation Internationale De L'Automobile) record that same meet. From left to right are Aron Oakes, Dan Waldrop, Julio Hernandez, Victor Arrequin, Derby Pattengill, Jake Doomey, and Brad White. (Courtesy of the Bean Bandits Collection.)

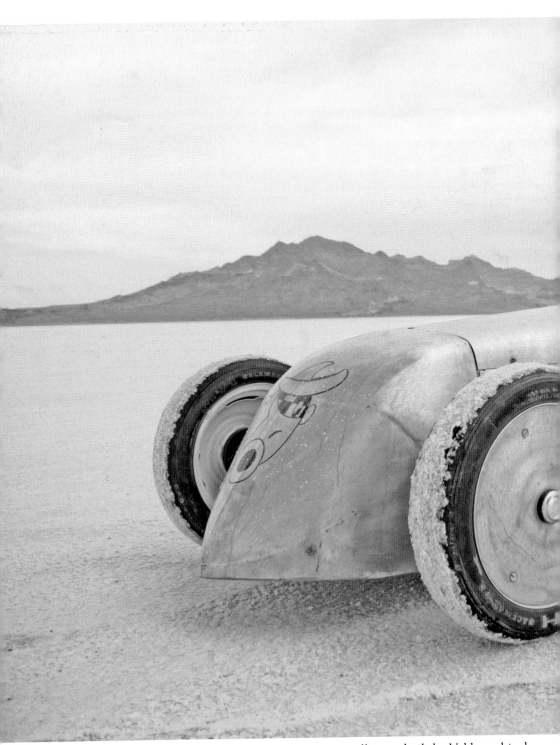

Fabian Valdez's roadster, pictured here in 2010 at Bonneville, was built by Valdez at his shop, Vintage Hammer Garage in Riverside, California. This 1929 hand-formed aluminum body running

THE NEW BEAN BANDITS

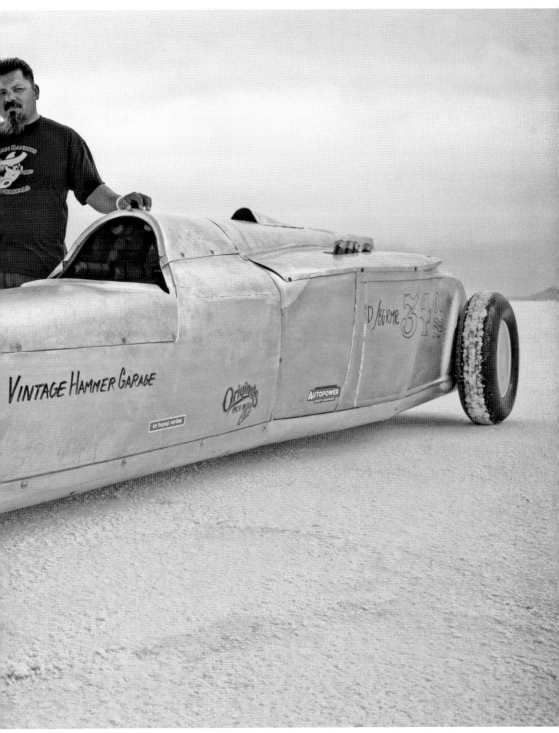

a 300-cubic-inch Chevrolet set three records at that meet with a top speed of 222 mph. (Courtesy of the Bean Bandits Collection.)

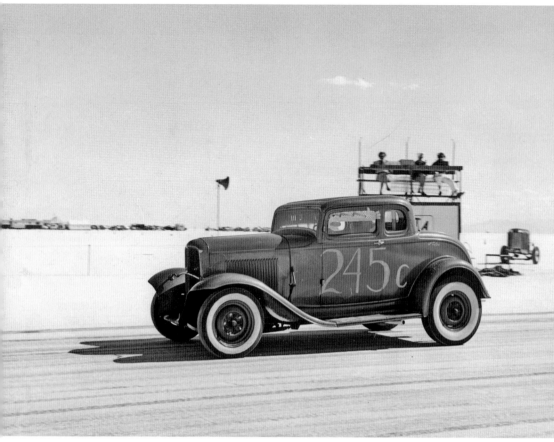

The book ends where it began: on the dry lakes and salt flats. As long as there is a stretch of land and a car, men and women will test their knowledge and skills and see how fast they can make it go. Lou Bingman's 1932 coupe is pictured during the 1953 Bonneville runs. Bingman would make several adjustments during the weekend event. His first run was 97 mph, and his last was 127 mph. (Courtesy of Lou Bingman.)

THE NEW BEAN BANDITS

Mike Nagem, pictured here wearing his Bob McCoy T-shirt, convened a meeting of hot rodders at his San Diego, Seaside Service Station in 1950 that led him and Fred Davies to acquire from Miss Adams the use of the Naval Outlying Landing Field at Paradise Mesa for $1 per year. So began one of the major pioneering moments in the American sport of drag racing. (Courtesy of the Bean Bandits Collection.)

DISCOVER THOUSANDS OF LOCAL HISTORY BOOKS
FEATURING MILLIONS OF VINTAGE IMAGES

Arcadia Publishing, the leading local history publisher in the United States, is committed to making history accessible and meaningful through publishing books that celebrate and preserve the heritage of America's people and places.

Find more books like this at
www.arcadiapublishing.com

Search for your hometown history, your old stomping grounds, and even your favorite sports team.